FALSIFICATIONS
AND
MISRECONSTRUCTIONS
OF PRE-COLUMBIAN ART

FALSIFICATIONS
AND
MISRECONSTRUCTIONS
OF PRE-COLUMBIAN ART

A Conference at Dumbarton Oaks

OCTOBER 14TH AND 15TH, 1978

Elizabeth P. Benson, *Organizer*
Elizabeth H. Boone, *Editor*

Dumbarton Oaks

TRUSTEES FOR HARVARD UNIVERSITY

Washington, D.C.

Library of Congress Cataloging in Publication Data
Main entry under title:

Falsifications and misreconstructions of Pre-Columbian art.

Includes bibliographies.
1. Indians—Art—Congresses. 2. Forgery of
antiquities—Congresses. 3. Indians—Antiquities—
Conservation and restoration—Congresses. 4. Latin
America—Antiquities—Congresses. I. Boone, Elizabeth
Hill. II. Dumbarton Oaks.
E59.A7F34 702′.8′74098 82-5122
ISBN 0-88402-111-4 AACR2

Preface

THIS VOLUME contains many of the papers presented at the Dumbarton Oaks conference on falsifications and misreconstructions of Pre-Columbian art, organized by Elizabeth P. Benson, and held on October 14th and 15th, 1978. The purpose of the conference, and thus this volume, was to raise the issue of Pre-Columbian forgeries. A surprising number of falsified or largely reconstructed objects do exist in public and private collections and, in the case of architecture, in the public domain; many have been published in the literature as representative of Pre-Columbian artistic forms. The danger is that these recreations, unless identified as such, can distort our understanding of Pre-Columbian art and can lead to erroneous stylistic and iconographic interpretations. Thus the papers in this volume note the range of "antiquities" produced in relatively modern times, suggest why these were and still are being created, and show how such forgeries can be detected.

In his 1964 article, "The Problem of Fakes in Pre-Columbian Art" (*Curator* 7: 19–32), Gordon Ekholm mentioned most of the published studies pertaining to Pre-Columbian forgeries. These studies need not be reviewed again here, but it is clear that the subject has been sparsely treated. Yet forgeries have a considerable time depth. Ekholm noted that fakes created as early as the 1820s in Mexico were of concern to such scholars as W. H. Holmes, Francisco Plancarte, and Leopoldo Batres near the turn of the century. Esther Pasztory, in this volume, discusses the Mexican falsifications of the nineteenth century in greater depth and argues strongly for a reappraisal of some well-known pieces acquired during this period. It would seem that one can no longer argue for the validity of an object solely because it has a known history of some 150 years.

Falsifications can take many forms and can have their visual origins in any number of sources. Often a genuine object will simply be copied in the same medium, but as several of the articles included here point out, the

forger can easily translate the forms from one medium to another, recreating a ceramic vessel in gold or silver, for example. With the availability of numerous detailed drawings and high-quality photographs, forgers are increasingly likely to use published illustrations as their prototypes, especially where the designs are primarily linear, as with Moche fineline vessels or Recuay resist wares as reported by Donnan and Reichert. Occasionally iconographic details or more basic features of style from several sources are combined in a single product, but when a forger feels he has reached a certain level of expertise, he may create an entirely new object without the aid of specific prototypes and may even develop his own individual style. This seems to be the case with the Wari Forger mentioned by Sawyer.

The consensus of the conference was that forgeries can most efficiently be detected, not through scientific testing which is often financially unfeasible, but through an experienced comparison with objects known to be authentic. And here the stylistic and iconographic integrity of an object in question is crucial. Sonin and Sawyer primarily address failings of style, while Donnan, Reichert, and Pasztory point out iconographic inconsistencies. In these cases, the irregularities of the objects are subtle and are identifiable only because each author is well versed in the rules governing that particular form of visual presentation.

The detection of forgeries can also rest on a technical examination of an object (with the unaided eye, a microscope, or a more complex laboratory process) to determine whether a piece was created with the materials and in the technique known to be appropriate to that class of objects. Sonin notes the problems of a brass vessel alleged to be from a culture that did not use brass in that way, and Sawyer reminds us that the presence of oil-based paints would indicate at the least that a vessel has been repainted. Wassén demonstrates the importance of trace element analysis in determining relatively small deviations in the chemical content of a group of silver objects. As with the visual or stylistic-iconographic analyses, these technical examinations ultimately depend on an understanding of the parameters of genuine examples, and as Wassén makes apparent, each kind of analysis should complement the others.

Misreconstructions or inventive restorations can distort our understanding of Pre-Columbian art just as easily as can falsifications, for they imply a Pre-Columbian actuality that may not have existed: Taylor's article shows how perilous may be iconographic interpretations that are based on

Preface

largely repainted Maya polychromes, and Molina makes the unsettling point that some of the best known or more important architectural monuments in Mesoamerica are heavily reconstructed, so that cultural inferences drawn from them rely largely on conjecture.

A cautionary tone extends throughout the volume. The papers all imply, and some say directly, that care must be taken in verifying that interpretations or inferences—whether these interpretations be art historical or extend into the larger context of culture history—are based on objects of the Pre-Columbian past rather than on recreations of this past.

ACKNOWLEDGMENTS. The authors are grateful first to Elizabeth P. Benson for organizing the conference and to Junius Bird for chairing the sessions. Thanks go also to Anne-Louise Schaffer and Alex DeBoeck, who ensured that the meetings ran smoothly, and to Frances Nordbye, who assisted with editing the volume.

Elizabeth Hill Boone

THE PARTICIPANTS

Patricia R. Anawalt
Carlos B. Aróstegui
Elizabeth P. Benson
Janet C. Berlo
Junius B. Bird, *Chairman*
Peggy Bird
Victor Bortolot
Barbara Braun
Flora Clancy
Michael D. Coe
Sophie Coe
Christopher B. Donnan
Mary Ann Durgin
Gordon F. Ekholm
Marguerite Ekholm
Marta Foncerrada de Molina
Beatriz de la Fuente
Marilyn Goldstein
Gillett G. Griffin
Garman Harbottle
Julie Jones
Peter David Joralemon
Mary Elizabeth King
Alan Kolata

Arthur G. Miller
Augusto Molina Montes
H. B. Nicholson
Lee A. Parsons
Esther Pasztory
Marion Stirling Pugh
Jacinto Quirarte
Raphael X. Reichert
Donald Robertson
Richard Rose
Ann P. Rowe
Alan R. Sawyer
Anne-Louise Schaffer
Philippa D. Shaplin
Robert Sonin
Robert Stroessner
Dicey Taylor
Richard Townsend
Nancy P. Troike
Charles C. Uhl
S. Henry Wassén
Hasso von Winning
David Zimmerman

Contents

Contents

The Art Historian's Dilemma:
With Remarks Upon the State of Art Falsification in the Central and North Andean Regions
ROBERT SONIN

> *The forger is an impostor and a child of his time, who disowns the method of vision which is natural to him.*
>
> *After being unmasked every forgery is a useless, hybrid and miserable thing.*
>
> Max J. Friedländer

THE ART-FAKING INDUSTRY is flourishing as never before. The Pre-Columbian segment of the industry is uncommonly prosperous, and as interest in art collecting increases the art forgers are keeping busy, supplying a growing proportion of the items offered for sale. The forgers seem to thrive whatever the state of the economy, for in times of prosperity more people are able to collect art, and during recessions and periods of inflation people invest in art as property that will keep its value.

This paper is written not for the scholarly experts on art falsifications but for the wider public of collectors and art lovers. When an expert condemns a fake brought to him by an inexperienced collector, usually he must also explain the elementary facts of art faking. To this end, and recognizing the value of direct but guided observation, I offer a photo essay on specific forgeries, supplemented by some general comments on the faking of Peruvian, Ecuadorian, and Colombian art. In my discussions, I hope to warn the collector and curator to be on their guard, but since I hope also to avoid helping the forgers themselves, I have chosen not to publish much information about technical processes.

Twenty years ago the supply of art from the Andean area and most other New World regions was sufficient to satisfy the few collectors and

museums that bought them. But the recent spread of interest in Pre-Columbian culture has created a greater demand for objects of art, and the conditions are now nearly ideal for fakers. The supply of genuine art has not grown to meet the demand, for increasingly, the governments of the United States, Mexico, and Latin America are moving to curb the export and import of antiquities. The shortage is being compensated for by a larger production of counterfeits.

In the United States, museums, collectors, and dealers are fortunate in having a large number of specialists on whom they can depend to protect them from fakes. Other parts of the world, however, have fewer experts, and consequently their public and private collectors are regularly victimized. If a piece is turned down in the United States a dishonest dealer simply heads for Europe or the Far East, where he can find a buyer in this expanding market—without the inconvenience of an expert evaluation of the piece.

Forgers have two main sources for their models. The first are genuine objects. Some forgers are part-time dealers in art or are restorers and repairers of excavated objects, and they thus have real things to copy. If they are skillful, their work can be hard to detect, but when they attempt to create works of their own invention, the result is often ludicrous. The second common source for forgers is published illustrations, and we can visualize a counterfeiter at work with an open book before him. This kind of fake can be detected by a thorough familiarity with the literature on the subject and a good memory, although no amount of literary knowledge alone can take the place of the experience that comes from handling many genuine and false specimens.

PERU

The exporting of antiquities from Peru reached a peak around 1968. At that time the growing interest in ancient Peruvian art and the relatively permissive attitudes, official and unofficial, of various governments helped to stimulate sales of Peruvian art in the United States and Europe. *Huaqueros,* the traditional but unlicensed treasure hunters, plundered archaeological sites and even entire regions that had not been explored to any extent by trained archaeologists. The diggers seemed to be, and sometimes boasted that they were, virtually immune to prosecution. Government institutions seemed unable to stop the looting or to excavate a share of the material. Art forgery existed, even thrived, but it did not seriously

rival the trade in genuine art. The forgers were usually unskillful; they produced poor imitations, most of which were sold to tourists.

In 1968, however, a new government came to power in Peru and turned the large estates into something like state operated farms. The *huaqueros* could no longer devote much time to their old sideline. Then in 1972 the Instituto de Cultura established a special office to protect cultural resources, which began to prosecute some persons active in the trade of antiquities. However, the demand that had been created for Peruvian art continued, and the conditions that favor forgery—a demand that genuine art cannot fill—came into being. Fakes have thus become more plentiful and of better quality. The forgeries show greater skill and a much better sense of style. They account for a very large share of sales. I don't know if more fakes than genuine items are sold, but it is possible.

Gold fakes are more frequent than those of silver or copper, because more collectors want gold even if the artistic quality is lower than that of a silver or copper object. Gold is also easier to fake because it does not corrode as markedly as baser metals. The faked patinas of silver and copper frauds are what make them so easy to recognize.

Pottery fakes are always plentiful, with some emphasis on pornography. They range from carelessly made replicas of Chimu and Inca blackware (often made blacker with shoe polish) to very skillful imitations of Chavín, Moche, and Nasca vessels. In some cases only scientific tests, such as thermoluminescence testing, can confirm stylistic and iconographic analysis. In spite of the improvements, most forgers can be relied upon to commit some stylistic or technical error which eventually exposes them. Sometimes they become conceited and "improve" the styles they copy—they are discovered at once.

So far no serious attempt has been made to weave or embroider copies of ancient textiles, because even if a weaver had the necessary skill, the time and labor involved would make the task unprofitable. However, painted textiles are frequently faked. Old cloth from ancient burials are painted with simple earth colors and natural dyes, and if the forger is careful these are difficult to detect. Dreadful pastiches are made from assembled scraps of decayed or incomplete textiles; some important painted Chavín-style textiles from the South Coast have been treated this way, ruining them for study. Cloth dolls are made from scraps of textile and old spindle sticks and reeds, and now they are sewn with unraveled thread from old cloths. It was easier to spot them when the makers used

Robert Sonin

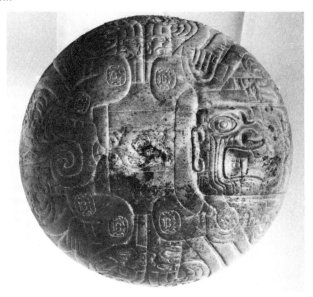

Fig. 1 Steatite bowl, Chavín style from the North
Coast of Peru, *ca.* 1000–400 B.C. Diameter 17.8 cm.
Photograph courtesy of the Brooklyn Museum.

modern thread; no doubt somebody showing off his expertise pointed out
the error to the seller, or merely allowed him to see it by the way he
examined the dolls.

Figures 1–3 show the original and two copies of a Chavín stone bowl
from the North coast of Peru, *ca.* 1000–400 B.C. The richly carved bottom
of the original in the Brooklyn Museum (Fig. 1) presents a snarling
semihuman monster who holds a severed human head in one hand and a
rectangular blade in the other. His body, seen displayed from above, is
decorated with other trophy heads. His rump is composed of a spiral shell
from which a serpent emerges.

A modern copy of the Brooklyn Museum bowl (Fig. 2) is made of a
different kind of stone. Its carving lacks the monumentality and the almost
baroque plasticity of modeling characteristic of the original. The forger
has failed to include any of the short teeth in the principal and subsidiary
heads. Only the crudely rendered fangs of the monster remain, and these
fail to extend over and press into the lips. The perpetrator of this aesthetic
crime, besides being a very poor observer, may have made such a bad job

4

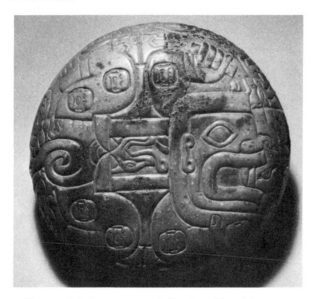

Fig. 2 Modern copy of the Brooklyn Museum bowl. Private collection.

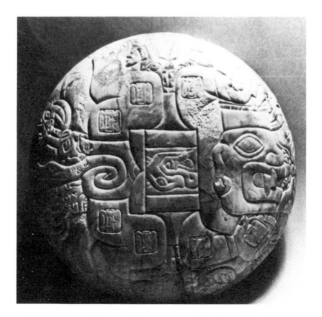

Fig. 3 Another modern copy of the Brooklyn Museum bowl. Private collection.

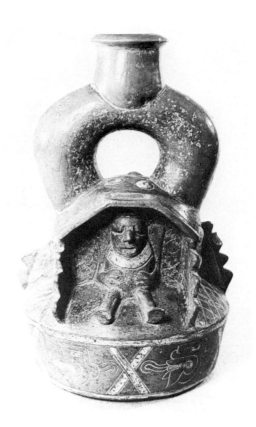

Fig. 4 Chavín stirrup spout vessel of red clay with details painted in white, *ca.* 800–300 B.C. Museo Amano, Lima.

of the teeth that he shaved them off as a lesser evil, or he may have worked from a bad photograph or drawing. He also tried to add a patina (dark blotches) to make the stone look ancient.

Another forgery—a second copy of the Brooklyn Museum Chavín bowl (Fig. 3)—appeared about a year after the first and was offered for sale in the United States. It shows more sensitivity to detail and greater skill in carving than the first copy. The serpent head in the central cartouche on the monster's back does have fangs, unlike the first copy, but the short teeth are still missing from this serpent head and from the head of the principal monster. The copyist has pecked at the surface of his bowl in an attempt to make the stone look eroded, but, like most forgers, he has confined the damage to unimportant areas of his work in order not to lower its market value.

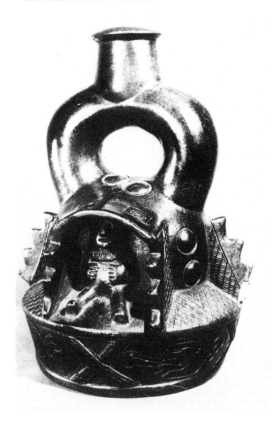

Fig. 5 Copy of the Chavín
vessel in the Museo Amano.

A Chavín stirrup spout vessel and its copy are shown in Figures 4 and 5. The original (Fig. 4), which has a red body and details painted in white, is in the Museo Amano in Lima. The forger in this instance is very skillful, and this makes his copy (Fig. 5) dangerous. Only a complete familiarity with Chavín art or an elaborate scientific test can usually expose this sort of forgery. The copy is made of smudged black pottery, for the forger may not have been aware that the original vessel is of red (oxidized) ware. Very likely he copied his vessel from a handbook on Peruvian archaeology where it is reproduced in black and white (Lumbreras 1974: Fig. 80) or he may have wished to obscure the similarity of his copy to the original by changing the color.

One of the best known and most often illustrated examples of Late Chavín modeled blackware is illustrated in Figure 6, with its copy in

Robert Sonin

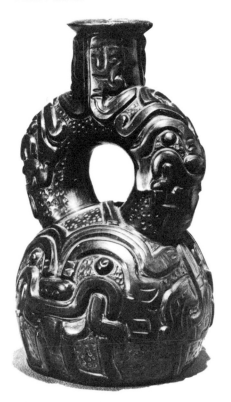 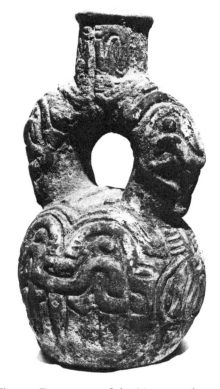

Fig. 6 Late Chavín modeled black-ware, *ca.* 500–200 B.C. Museo Nacional de Antropología y Arqueología, Lima (after Museums of the Andes 1981).

Fig. 7 Brass copy of the Lima vessel. Height 18.5 cm. Private collection.

Figure 7. Perhaps in a fit of madness, the forger cast this copy in brass—it weighs 2300 grams, a little over five pounds. The walls of the copy are extremely thick, and a false patina of corrosion has been applied to the surface with chemicals. It is not certain that copper had been discovered by the late stage of the Chavín culture, from which the ceramic original comes; the art of casting hollow containers and sculpture was never developed in Peru at all. A spectrographic analysis of a sample of the metal reveals that the alloy of the forgery has a one-to-five percent zinc content. This type of low-zinc brass is sometimes called "gilding brass," and it is used mainly to make tubing and cheap jewelry which is to be gold plated. Zinc was entirely unknown to the Pre-Columbian world.

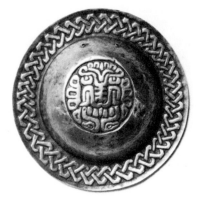

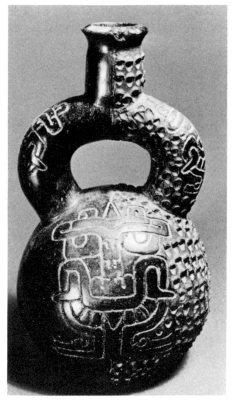

Fig. 8 *above* Disc pendant of hammered and embossed gold, Late Chavín, *ca*. 400–200 B.C. Dumbarton Oaks.

Fig. 9 *right* Blackware vessel patterned after the Dumbarton Oaks pendant, created as a prank.

If pottery can be translated into metal, so can a gold pendant (Fig. 8) be translated into a blackware vessel (Fig. 9). This fake blackware stirrup spout vessel with incised and punctate decoration (Fig. 9) was made as a prank by a student and was shown to several experts as a practical joke. The feline head with serpents forming the lower lip was deliberately copied from the Dumbarton Oaks gold disc pendant as a clue to the victims of the joke. Such jokes can sometimes get out of control if the item is too eagerly accepted by an authority or if it eventually finds its way into the art market.

More serious, however, are the forgeries of the Moche ear ornaments in the Museo Larco Herrera in Lima (Fig. 11). The originals (Fig. 10) are of

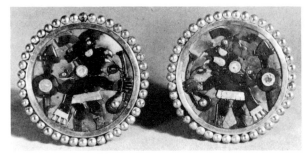

Fig. 10 Gold ornaments, Moche, *ca*. A.D. 100–550. Museo Rafael Larco Herrera, Lima.

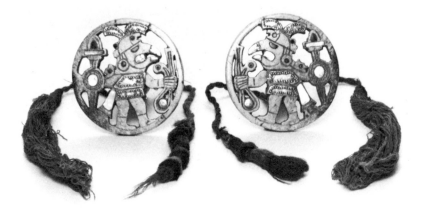

Fig. 11 Copies of the Larco museum ornaments. Private collection.

hammered and soldered gold, set with mosaic pictures of hawk-headed warriors armed with shields, clubs, and slings containing balls of gold. The figures of the originals are composed of chrysocolla for the bodies, lapis lazuli (greyish) for the feet, calcite in the shields and earplugs, pink shell for the skirts, and gold for details such as the beaks, eyes, and tassels; all of this was set into a ground of fitted turquoise. The hollow beads were soldered to the rim, and long hollow gold tubes were soldered to the gold backing. In contrast, the forgeries are made of bone embellished with bits of gold and mother-of-pearl and green stones. The workmanship is very inferior. The tassels attached to the fake earplugs are genuine and of a period later than the Moche originals.

A "Chimu style" gold panpiper is clearly revealed as a forgery by its crude execution (Fig. 13). The original, in the Metropolitan Museum of

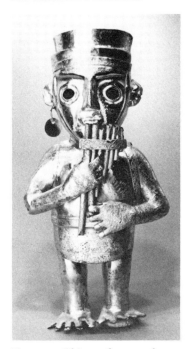

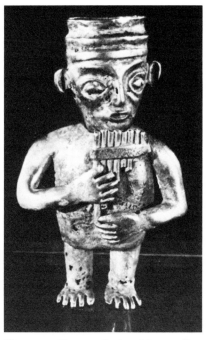

Fig. 12 Chimu figure of a man playing a panpipe, *ca.* A.D. 1250–1470, embossed and soldered silver with turquoise eyes, height 21.7 cm. Metropolitan Museum of Art.

Fig. 13 Copy of the Metropolitan Museum panpiper, in gold. Private collection.

Art (Fig. 12), is formed of embossed and soldered silver (for the Chimu never cast silver figures of this size—21.7 cm.) and has inlaid turquoise eyes. The copy is poorly cast in two parts in a low grade gold alloy. No attempt has been made to add a patina of age to the poorly finished metal. The separately cast head is not technological bravura, but simply a device that made the casting easier. The holes in the legs are not meant to imitate the corroded areas of the original figure; they are merely the result of a poor casting. The original Metropolitan Museum figure appears on the dust jacket of a widely distributed book on the ancient art of South America (Lapiner 1976). It seems to have appealed to a forger in another country, for the copy was most likely made in Colombia where hollow casting is often done.

Figures 14 and 15 show a more subtle translation from pottery to metal than is seen in Figures 6 and 7; the little modeled group at the top of the

Fig. 14 Inca double-chambered blackware vessel, *ca.* A.D. 1460–1521. Museo del Sitio de Pachacamac (after Jiménez Borja 1961).

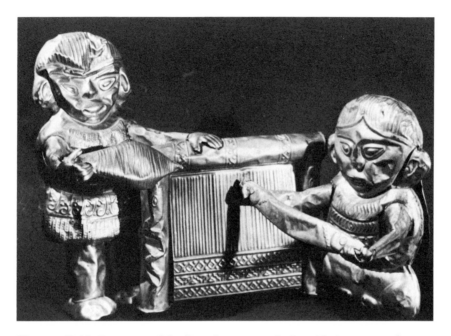

Fig. 15 Gold alloy copy of the figural group on the Inca blackware vessel.

closed neck of an Inca double-chambered blackware vessel (Fig. 14) has served as the prototype for a figural group in gold (Fig. 15). The modeled group of the Inca original, *ca.* A.D. 1460–1521, depicts a man overseeing the work of two women at an upright loom (Fig. 14). This may be the only representation of this type of loom in Pre-Conquest Peru. The vessel was excavated at Pachacamac on the Central Coast in 1958 by Arturo Jiménez Borja and first published in 1961. It is on exhibition in the site museum at Pachacamac (Vanstan 1979: 233). The fake group (Fig. 15) is of embossed and soldered machine-rolled gold alloy. One can see that the loom and the hand of the standing male that rests on the loom are clearly derived from the pottery vessel. The forger has omitted one of the women and has repeated the position of the man's other hand by placing a spindle in it. The woman now holds in her hands an absurd double-headed fish that may be meant to represent a weaving sword or beater. The forger did not have enough ambition or skill to copy the warp threads being pulled outward from the loom, as is shown in the Inca vessel, so he busied the woman with something else. This group, with simian faces and ears and

made of mechanically-rolled sheets of metal that have been deliberately pocked with dents, is usually credited to a well-known forger who worked for many years in Lima prior to 1964 (or to his workshop).

<p style="text-align:center">ECUADOR</p>

The recent political and economic changes in Peru have had a great affect on the art market in Ecuador and Colombia. As material became scarce in Peru, many art dealers turned their attentions northward. Their competition with local Ecuadorian collectors caused a rise in prices which stimulated the search for antiquities. The gap between the demand for such art objects and the number available, plus the stimulation of rising prices, created the proper climate for forgery. Pottery figurines from all the major periods and regions have appeared. Some of these fakes bring higher prices than do genuine examples because they are more complete or in "better condition." Valdivia, Tolita, Jama-Coaque, Manteño, and Car-chi styles are all imitated.

Gold forgeries from Ecuador are not numerous, especially in comparison with Peru's and Colombia's output. Perhaps a low level of interest or an adequate supply of genuine objects has made modern production on a large scale unnecessary. The gold forgeries that have appeared have been inept.

<p style="text-align:center">COLOMBIA</p>

In recent times Colombia has become a very active center of art forgery. Increased activity was stimulated at first by the decline of activity in Peru and Mexico, where legal restrictions made dealers in genuine antiquities look for new areas to exploit. Now the art market in Colombia flourishes by itself, and the faking industry is even more prosperous than the market for genuine art.

Gold fakes are produced in greater numbers in Colombia than in any other nation in the Western Hemisphere. They range in quality of workmanship, from incredibly crude pieces to imitations that are so skillful only the most experienced (and obstinate) experts can detect them. Both extremes are frequently found side by side in the same collection, sometimes with the same kind of bogus "certificate of authentication." The issuing of all kinds of documents of authenticity, some with elaborate, wavy, engraved borders like stock certificates, is an industry itself. After a

buyer has been cheated by a dealer in fakes, he is sent to a dealer in certificates who then adds the insult to the injury.

Pottery fakes include copies of Tairona effigy whistles (usually a little too elaborate), some of which command prices higher than are asked for real ones. Some of these bogus Tairona effigy vessels are made with black lacquer finishes that dissolve in paint remover in spite of the genuine roots still found on the insides of the vessels. Fantastic animals and monsters, which are usually a mixture of Momil and Puerto Hormiga styles with some Barlovento elements added, are sold as examples of Momil art. In the south, seated figures with coca cuds in the cheek, good imitations of the Nariño style, sell briskly; they are often fired too hard, and the forgers don't know how to reproduce the resist decoration of real Nariño pottery.

When forgeries are copied from genuine objects, they often reproduce or misinterpret the damaged condition of the originals. This has happened with a Calima-style finial of a bodkin or lime dipper (Fig. 16) and its copy (Fig. 17). The original finial is composed of two gold alloys, one that is a nearly pure, pale yellow gold and another that is a low karat copper-gold alloy (*tumbaga*) that was cast onto the high karat metal with a technique that required exquisite control and skill. The low karat red-gold alloy or *tumbaga* has corroded, and in some places parts have fallen off, as at the ends of the arms and lower left spiral of the headdress. Not understanding the decay caused by corrosion, a forger has blindly copied, in his awkward way, these archaeological alterations (Fig. 17). He has even soldered his figure to a brass shaft; when polished, brass can be mistaken for gold by an inexperienced buyer.

Another forged Calima-style finial is shown on the left of Figure 18. It is a very poor imitation of a genuine example in the Museo del Oro in Bogota with which it is shown (on the right). The forgery was copied from a color plate, in an early publication of the museum, which was not sharply detailed. The color plate illustrates a remarkable articulated bird, the body of which is mounted on wires so that it bobs up and down, which sets the flat tail in motion. The whole artful contraption is mounted on a tiny cast finial. The chickenlike "tail" is really a stylized representation of the wing. The ignorant forger of the copy (Fig. 18, left), who could have discovered all this by reading the text, has made his copy from embossed sheets of gold that he has soldered together; the soldered joint can be seen on his sheet metal version of the finial under the bird. He

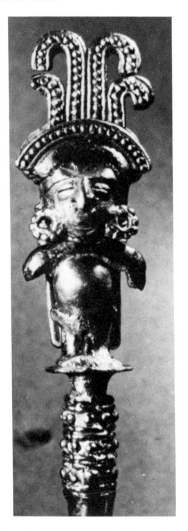 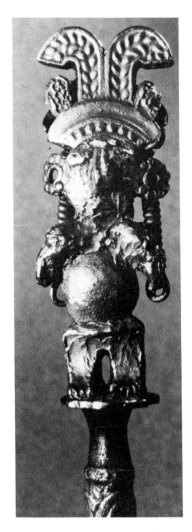

Fig. 16 Finial of a bodkin or lime dipper, Calima style, Colombia. Didricksen Art Foundation, Helsinki.

Fig. 17 Copy of the Didricksen bodkin/lime dipper. Private collection.

Fig. 18 A forgery (*left*) photographed in front of the pub-
lished illustration of its source (*right*), which is a Calima style
finial of a bodkin or lime dipper. Original in Museo del Oro,
Bogota (after Santos 1948: Pl. 33).

thought the folded wing was the tail, and since he did not know what to
make of the thin, bright line that is actually the lighted edge of the fore-
shortened flat tail, he added a meaningless rattail to his pitiful copy. Not
understanding the significance of the break in the leg of the original bird—
where the wire is attached to mount the movable body—he put a useless
break in his bird's leg too. A final bit of brazen effrontery is the substitu-
tion of a brass rod in place of the gold shaft of the original. The unlucky
purchaser is thereby cheated twice—a false bird, and brass instead of gold.

In summary, the honest but inexperienced collector should be warned to
trust nothing he hears about a particular piece from its seller and only part
of what he sees.

Robert Sonin

BIBLIOGRAPHY

Jiménez Borja, Arturo
 1961 Caracter ancestral de la artesana peruana. *Fanal* 16 (61): 13–18. International Petroleum Co., Lima.

Lapiner, Alan
 1976 *Pre-Columbian Art of South America.* Harry N. Abrams, New York.

Lumbreras, Luís G.
 1974 *The Peoples and Cultures of Ancient Peru* (Betty J. Meggers, trans.). Smithsonian Institution, Washington.

Museums of the Andes
 1981 *Museums of the Andes.* Kodansha Publishing and Newsweek Books, Tokyo and New York.

Santos, Gustavo (introd.)
 1948 *El Museo del Oro.* Banco de la República, Bogota.

Vanstan, Ina
 1979 Did Inca Weavers Use an Upright Loom? In *The Junius B. Bird Pre-Columbian Textile Conference* (Ann Pollard Rowe, Elizabeth P. Benson, Anne-Louise Schaffer, eds.): 233–238. The Textile Museum and Dumbarton Oaks, Washington.

The Falsification of Ancient Peruvian Slip-decorated Ceramics

ALAN R. SAWYER

UNIVERSITY OF BRITISH COLUMBIA

ALL WHO ARE INVOLVED in the detection of Pre-Columbian art forgeries, whether Mesoamericanists or Andeanists, face similar problems and employ essentially the same methods. The objects they are asked to judge are, without exception, lacking in scientifically established provenience and association. The ability to recognize a falsification ultimately rests on whether or not one's understanding of style, iconography, and technology is more complete than that of the forger. When it is, the specialist is able to identify mistakes and expose the attempted deception. If errors cannot be detected the object is accepted as genuine, is often exhibited and published, and becomes part of the criteria by which other works are judged. The accumulative effect of undetected forgeries can seriously distort our perceptions of ancient art styles.

As a group, Pre-Columbian experts can claim a very high success rate, pointing out that it is only the work of the "master forger" that is sometimes undetected. Unfortunately, the efforts of highly skilled forgers increase in direct relationship to the rarity, demand, and prices paid for "important" Pre-Columbian objects. Both the quantity and quality of master forgeries in the market place has risen steadily during the past century.

The type of falsifications confronting the Mesoamericanist and the Andeanist differ in important respects due to historical, geographical and cultural factors. The archaeological record of Mesoamerica is more completely understood than that of the Andes since it has been under investigation over a much longer period of time. Because of the area's greater accessibility to Europe and North America, interest in its antiquities, on

the part of museums and collectors, began earlier and has been more intense. It follows that until recent decades there has been a more active production of high quality falsifications in Mesoamerican styles than in those of the Andean area.

Over the past four and one-half centuries, nearly all of the archaeological sites in the area that comprised the Inca empire have been repeatedly and systematically looted. The pillage may be divided into three phases according to what was sought. During the first, beginning with the Conquest and extending throughout Colonial times and well into the Republican period, objects of gold and silver were gathered to be melted down into bullion. The second phase was inaugurated by the pioneering archaeological explorations of Ephraim George Squier in 1863–1865 (Squier 1877). His discoveries stimulated the desire of European and North American museums to acquire Andean antiquities for their collections. The efforts of the archaeologists they sponsored were soon surpassed and often frustrated by the ubiquitous *huaqueros* (professional looters) who quickly moved to profit from the new demand. The third and present phase began in the 1950s with a rapidly escalating interest in Andean antiquities as objects of art.

The falsification of almost every type of Andean artifact (except textiles of complex technique) began in the second (Antiquity) phase and greatly intensified in the third (Art) phase as the supply of important Andean art objects was exceeded by demand and as prices soared. High profits greatly encouraged the efforts of master forgers, and their production in the past decade has overwhelmed the capacity of Andean art specialists to prevent their being included in prestigious collections and their being illustrated in an ever increasing number of publications. To demonstrate the evolution of this crisis situation, I will briefly describe the history of a single type of art forgery: the falsifications of ancient Peruvian slip-decorated ceramics.

In 1901 the archaeologist Max Uhle excavated the first scientifically recorded Nasca graves. The material he recovered went to the Lowie Museum at Berkeley, and in 1905 he was asked to return to the South Coast to obtain an additional collection. He found that his discovery had triggered a demand on the part of foreign museums for Nasca material which in turn had set off an intensive campaign of huaquero activity in the South Coast cemeteries. Uhle was not permitted to dig and was forced to purchase material from the looters. The quantity of Nasca ceramics and other materials recovered by huaqueros in the early years of this century

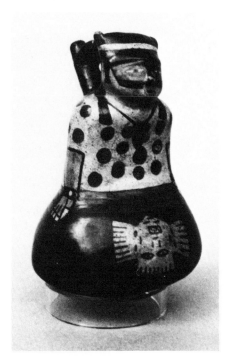

Fig. 1 False restoration. Fragments of two Nasca ceramics combined and overpainted. Present location unknown.

was enormous, and most of the major Nasca collections in the world's museums were assembled during this period. Many ceramics were broken or damaged when found, and the conversion of these to saleable items caused the profession of ceramic restoration to flourish.

Restoration methods at the beginning of the century were primitive by today's standards and made it easy for the restorer to falsify the original design and nature of an object in an attempt to make it more saleable. The standard procedure was to mend broken pottery using thick shellac as an adhesive; next, poorly matched joints were smoothed down with sandpaper, often removing much of the original surface; and finally, designs that often departed radically from the original iconography were then executed with oil-based paint. Some false restorations combined parts of two or more ceramics to create a more complex form and were decorated with motifs drawn from several different Nasca periods (Fig. 1). In the light of today's knowledge of Nasca iconography and technology, these early falsifications are obvious. Even if the iconography was carefully copied from an original, brush strokes in the oil paint can be detected by

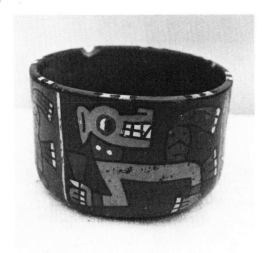

Fig. 2 Wari ceramic, Ica-Pachacamac style with profile feline motif. Private collection, Ocucaje.

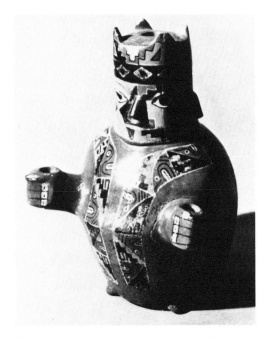

Fig. 3 Wari ceramic figure showing shirt mot-ifs. Amano Museum, Lima.

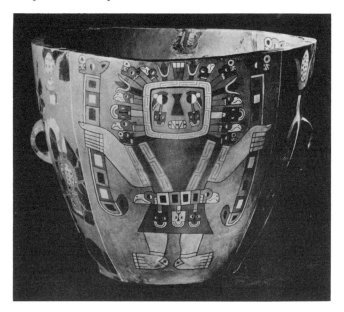

Fig. 4 Wari ceremonial urn from Pacheco. American Museum of Natural History, Photograph courtesy of A.M.N.H.

visual examination under raking light, and the paints themselves are easily removed with solvents. X-ray photographs clearly show hidden assembly joints and added details.

As the twentieth century progressed, some of the more talented ceramic restorers instituted improvements in their methods which made their restorations, false restorations, and outright forgeries more difficult to detect. Careful attention was paid to the resurfacing of the mended ceramics, and slip decoration was replicated with water-based paints and then sealed with a coat of clear lacquer. In a variant of this technique, mineral pigments were mixed directly with the lacquer and carefully blended to duplicate slip colors. Lacquer dries to a hard glossy surface and resists most solvents. The simplest way to detect it is to expose it to a flame which will cause it to blister whereas slips do not (Junius B. Bird, personal communication, 1959).

During the 1920s and early 1930s a series of discoveries of "Coast Tiahuanaco" (Wari) ceramics, at Pachacamac (Fig. 2), Ocucaje (Fig. 3), Pacheco (Fig. 4), and other sites excited the interest of museums and private individuals who sought examples for their collections. A highly skilled

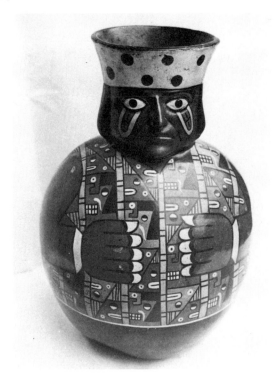

Fig. 5 Wari forgery built on a Moche head-neck jar. Private collection, Lima.

restorer, whom we shall refer to as the "Wari Forger" sought to supply them. Early examples of his work include false restorations that are totally resurfaced ancient ceramics painted with Wari designs. An example of this type (Fig. 5) utilized a Moche head-neck jar which he carefully modified and resurfaced with plaster and then painted with lacquer paints. The forger derived his concept of Wari style from ceramics submitted to him for restoration and from those he could find in collections and publications. He made no distinction between the various Wari styles now recognized (Menzel 1964), and he liberally extended his knowledge with creative imagination. In painting the modified Moche head-neck jar in Figure 5, he gave it a poncho that is far more elaborate than those found on genuine Wari examples (Fig. 3). In addition to his own version of a standard motif consisting of stylized human faces paired in opposing trian-

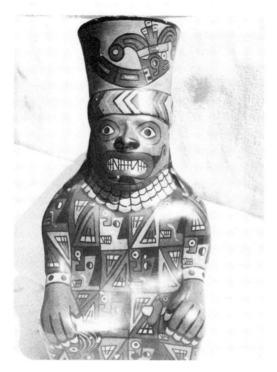

Fig. 6 Wari forgery built on a Moche figure jar.
Private collection, Sao Paulo.

gles, he incorporated a motif of his own. This was derived from a Wari profile feline head motif (Fig. 2) but embellished with an interlocking nose element and a heavy drooping "Cantinflas" moustache. All of the split eyes on the shirt motifs were incorrectly divided horizontally rather than vertically and the N-shaped fangs, standard to the profile feline motif, were omitted.

Another, perhaps slightly later creation of the Wari Forger, was built upon a Moche seated figure jar, extended by the tall spout of another vessel (Fig. 6). The aberrant "Cantinflas" motif is repeated, this time with proper dentures and correctly oriented eye. It is alternated with another invented motif: an invert-repeat of a fanlike triangle, which is not found on Wari tapestry shirts or their ceramic versions. The headdress design is an elaborate version of a feline-serpent motif found on Wari vessels. The collar of

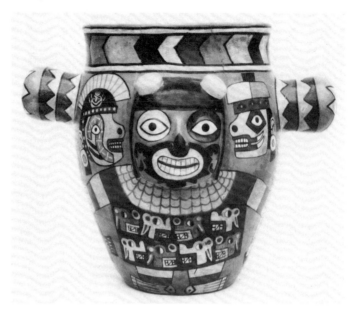

Fig. 7 Restored Wari urn. Museum of the American Indian, Heye Foundation. Photograph courtesy of M.A.I.H.F.

the figure and the markings of the reworked face were probably inspired by a large urn the forger had evidently restored (Fig. 7) which is now in the collection of the Museum of the American Indian, Heye Foundation.

Because of their unusual form, iconography, and lacquer painted surfaces, the Heye Foundation urn and several closely related ceramics have been generally regarded as the work of the Wari Forger. In an examination conducted by Robert Sonin and Anna C. Roosevelt (Roosevelt 1974) selected areas of the lacquer on the Heye example were removed revealing slipped surfaces beneath. A thermoluminescence test showed the ceramic to be of the correct age. The piece was thus proved to be genuine though restored, but the remainder of the lacquer may have to be removed before it can be determined whether or not the restoration accurately follows all of the original iconography. The other pieces of this suspect group must also be subjected to thorough examination and analysis to determine whether they are genuine, false restorations, or variants produced by the Wari Forger.

Both of the falsifications we have discussed (Figs. 5, 6) are superbly crafted, with careful attention to the refinement of their surfaces and pre-

cise rendering of their painted decoration. Since they were built on ancient ceramics, their unaltered interior surfaces give them a convincing aura of authenticity. Their iconographic errors are now apparent with today's better understanding of Wari styles, but such forgeries were eagerly purchased and treasured by collectors of the 1930s and 1940s, and many owners still refuse to believe they are false.

The Wari Forger was evidently greatly encouraged by success; his masterful falsifications had brought high prices and had found their way into collections throughout the Americas and Europe. He then began to make his own ceramics which were thick-walled like Wari ceremonial wares (Fig. 4) but much more highly fired. An outstanding example of this phase of his work is a large kero-shaped vessel in the collection of the Textile Museum in Washington, D.C. (Fig. 8). It was acquired by George Hewitt Myers, the museum's founder, in 1937 for the sum of $5000 and was accompanied by a letter of authentication from Wendell C. Bennett. While this letter, now in the Textile Museum files, stated reservations concerning the then current understanding of the Wari style, the author could find no reason for not accepting the piece as genuine. In 1943 it was published in Pal Kelemen's important book *Medieval American Art* (1943: Pl. 165b), and three views of it appeared in Bennett's (1946: 127, Fig. 14) definitive essay in the *Handbook of South American Indians*.

Considering the endorsement of such an eminent authority as Wendell C. Bennett, it is not surprising that the Myers vessel became a standard example of Wari art. Following his comment on the large reconstructed Pacheco bowl shown in our Figure 4, Kelemen (1943: 209–210) had this to say about the Myers forgery:

> . . . the pottery urn shows the same stylistic characteristics, but somewhat loosened. The winged figure here is doubtless the same as is sculptured in relief on the Gateway of the Sun. This is not a particularly ingratiating art to our eyes, but we must admit a powerful primeval concept behind these expressions. The certainty of the design and the fastness of color are admirable; the excellent quality of the pottery—it rings like crystal when tapped—and the fine polish make it striking. Even though the idea behind the presentation is largely obscure to us, it is clear that those who fashioned such pieces knew what they wanted and were without question able to express it with good decorative feeling.

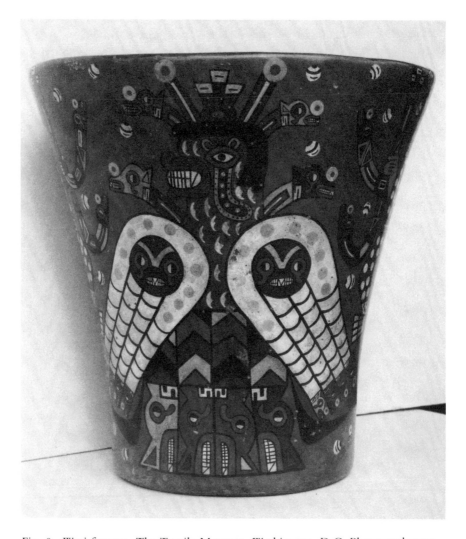

Fig. 8 Wari forgery. The Textile Museum, Washington, D.C. Photograph courtesy of the Textile Museum.

Fig. 9 Drawing of Wari gold pendant (after Tello 1923: Fig. 93).

Kelemen's favorable assessment is understandable in view of the time in which it was written and the extraordinary craftsmanship exhibited by this and other works of the Wari Forger. In effect, he had created a whole new iconography of his own, related to, but distinct from, that of the style he emulated. Consider, for example, the winged figure displayed on one side of the Myers forgery (Fig. 8). Though it exudes barbaric vigor, I find it radically different from the figures on the Gateway of the Sun at Tiahuanaco. The snarling visage has its N-shaped fangs placed in the corner of the mouth rather than at the front, and the frontal faces in the wings exhibit M-shaped fangs which are without precedent in either Tiahuanaco or Wari art. All of the split eyes in the feline as well as frontal heads have their white portion towards the snout or center of the face, an alignment diametrically opposite to standard (Fig. 4). It is quite possible that the forger drew his inspiration for this bizarre image from a drawing of a gold pendant (Fig. 9) published by Julio C. Tello (1923: Fig. 93). The wing pattern may have been suggested by the collar design on a textile illustrated in the same publication (Tello 1923: Pl. 2.).

It is presently impossible to estimate the number of works by the prolific Wari Forger that are included in the world's collections and publications of Andean art, but it is substantial. The acceptance and publication of his falsifications has radically distorted the stylistic criteria by which Wari ceramics have been judged and has led to the admission of additional forgeries. To purify our sample, all lacquer-painted Wari pieces must be thoroughly examined and analyzed to determine whether they are restorations, copies, false restorations, or outright forgeries. It will probably be many years before the confusion caused by this master forger is finally eradicated.

Up until 1960 it was generally assumed by Peruvianists that no forger was capable of duplicating Andean slip decoration techniques. In that year I encountered a strange loop bottle in a Lima collection (Fig. 10) which displayed a Middle Nasca (Dawson's Nasca 5) motif on one side and a late Nasca Proliferous (Dawson's Nasca 6) motif on the other (see Roark 1965: Pl. IX, Fig. 45 and Pl. XIV, Fig. 62). The ceramic was poorly polished and exhibited firing cracks, and the slip colors had a pale washed-out appearance. I convinced the owner that the piece was a forgery and brought it back to the United States to show my colleagues. Most were reluctant to accept the piece as false until more examples exhibiting the same types of technical and iconographic errors began to appear on the market. Robert Sonin nicknamed their creator "Flambo" because of the forger's predilection for extravagant forms and elaborate iconography. He has since been identified as a potter living near the town of Nasca. His falsifications enjoyed considerable success during the 1960s but are easily identified by anyone familiar with the Nasca style because of their pale slip colors, imperfect firing, thin walls and mixed iconography (Fig. 11). Although the forger was evidently the first to replicate the Nasca slip-decorated technique for commercial purposes, his works are now known to all Andean specialists.

In 1972 I was asked to authenticate a group of Nasca ceramics offered to a museum in the eastern United States. A typical example of this group is a handsome falcon effigy bottle (Fig. 12). Its dense slip colors and precise execution give it the appearance of an early Nasca ceramic in pristine condition. Detailed study, however, and comparison with genuine Nasca renditions of the same subject (Fig. 13) soon revealed a number of discrepancies.

The clay used to form the false falcon bottle is properly micaceous and well oxidized but softer and more brittle than genuine Nasca ceramic. The

Fig. 10 Nasca forgery, 1960, with Middle Nasca motif on one side (*left*) and Late Nasca motif on the other (*right*). Collection of the author.

Fig. 11 Group of Nasca forgeries, 1963. Collection of the author.

31

Fig. 12 Nasca forgery, 1971. Present location un-
known. Photograph by Sally Klass.

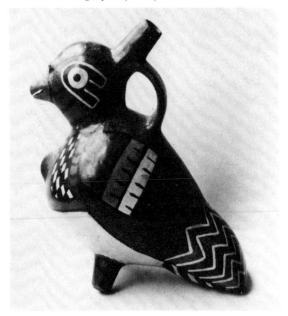

Fig. 13 Nasca falcon bottle. Private collection,
Lima.

slip colors faithfully replicate those of ancient examples but are more varied than is usual and some are thinly applied (for example, on the back and head), allowing the base clay to show through. The polishing is good but below Nasca standards. The stylized treatment of the wings and tail follow Nasca conventions quite closely, but like the head and beak forms, they have been simplified. The falcon eye and its markings are improperly rendered. In summary, the vessel is quite well done technically, but the subject is incompletely understood. What has been produced is a gentle dove rather than a vigorous falcon (compare Figs. 12, 13). The other ceramics in this group exhibited similar minor flaws. Each is beautifully done, highly decorative and based on a well known Nasca subject, but lacks the true dynamics of Nasca iconography.

In 1978, while in Lima, I was able to identify the creator of these vessels as an artist named Zenón Gallegos Ramírez, whose works were exhibited at a prominent Lima gallery in 1977. The exhibition catalogue (Amaru 1977) gives interesting details concerning his career and working methods. After attending various art schools and a brief career as an artist and teacher, he turned to ceramic restorations in the town of Nasca for his livelihood. His art training led him to analyze ancient production techniques through a study of broken Nasca pottery. He became convinced that he could replicate the ancient style, and he diligently located proper clays and slip materials native to the South Coast. He studied Nasca ceramics in Peruvian collections and publications and in 1971 began to make "replicas" of ancient Nasca pottery. He had made over two thousand of them by the time of his 1977 exhibition.

A comparison of the artist's Nasca style ceramics purchased in Lima in 1978 (Figs. 14, 15) with his early works examined six years previously reveals some progress in technique but little change in the iconographic weakness previously noted. The ceramic is still soft and brittle, probably due to his preference for an expedient method of firing with kerosene. His slip colors are excellent and are considerably more dense but tend to build up so that they may be seen in relief with raking light. The final polishing is good, but still falls short of the perfection exhibited by comparative ancient wares (Fig. 14). The iconography closely follows genuine models but contains minor errors (Fig. 15) apparent to the Nasca specialist or to the non-specialist who closely compares the Gallegos versions with genuine pieces.

Zenón Gallegos Ramírez is obviously proud of his creative and technical

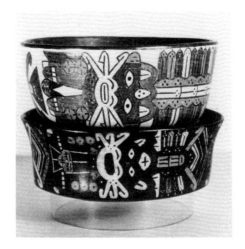

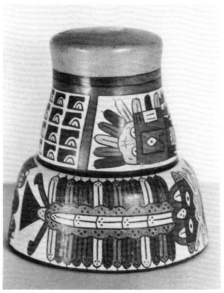

Fig. 14 Nasca forgery, 1978: (*above*) placed on top of a genuine example from the Pisco Valley; (*below*) placed beneath a genuine example from Cahuachi, Nasca Valley. Collection of the author.

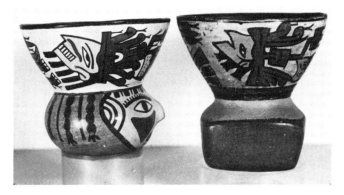

Fig. 15 Nasca forgery, 1978 (*left*), and genuine example (*right*) shown for comparison. Collection of the author.

abilities, and I have no evidence indicating that he has attempted to represent his works as genuine antiquities. The problem is that they are so well done that in the hands of an unscrupulous dealer they can be convincingly presented as ancient Nasca pieces. Many of Gallegos's works have appeared on the international art market over the past decade and have found their way into collections and publications in increasing numbers. There are simply not enough qualified specialists to control the situation, and our Nasca sample is being diluted and distorted with spurious material. Such contamination cannot fail to distort our understanding and appreciation of the Nasca culture that produced one of the most splendid ceramic styles of Pre-Columbian America.

Our problem does not end with ceramic falsification in the Nasca style. There are a number of other master forgers active in Peru today whose works are equal if not superior in quality to those of Gallegos. Some of the best work is in the Chavín and Moche styles. All of these recent falsifications can be detected by thermoluminescence, but their number is so great we must rely primarily on the "educated eye" of the specialist. This "eye" is backed by years of careful analysis of the iconography and technology of genuine ancient ceramics. To be effective it must go beyond superficial traits to the analysis of the quality and use of line, color, positive and negative space, and form relationships. Only through sensitivity to such factors can one come to appreciate the unique character of expression transmitted through an ancient art style that speaks of its culture's taste and values rather than those of our own.

BIBLIOGRAPHY

AMURA, RAUL
 1977 *Zenón Gallegos Ramírez.* Galeria Huamanqaqa, Lima.

BENNETT, WENDELL C.
 1946 The Archaeology of the Central Andes. In *Handbook of South American Indians* (Julian H. Steward, ed.) 2: 61–147. *Smithsonian Institution, Bureau of American Ethnology, Bulletin* 143. Washington.

KELEMEN, PÁL
 1943 *Medieval American Art.* Macmillan, New York.

MENZEL, DOROTHY
 1964 Style and Time in the Middle Horizon. *Ñawpa Pacha* 2: 1–106. Berkeley.

ROARK, RICHARD PAUL
 1965 From Monumental to Proliferous in Nasca Pottery. *Ñawpa Pacha* 3: 1–92. Berkeley.

ROOSEVELT, ANNA C.
 1974 A Polychrome Urn from Peru. *Indian Notes* 10 (1). Museum of the American Indian, Heye Foundation, New York.

SQUIER, E. GEORGE
 1877 *Incidents of Travel and Exploration in the Land of the Incas.* Macmillan, London.

TELLO, JULIO C.
 1923 Wira Kocha (Continuación. Con illustraciones.) *Inca* 1: 583–606. Universidad Mayor de San Marcos, Lima.

The Identification of a Moche Fake Through Iconographic Analysis

CHRISTOPHER B. DONNAN

UNIVERSITY OF CALIFORNIA AT LOS ANGELES

IN APRIL 1974, a remarkable Moche ceramic bottle (Fig. 1) was brought to the University of California at Los Angeles by an art dealer who thought we might be interested in including photographs of it in our Archive of Moche Art. I clearly recall that my first impressions of the bottle were very positive: in size, form, weight, surface texture, and color it was exactly like many authentic pieces that I had previously seen. The small breaks on the ring base, as well as the spalled and abraded areas on the spout, revealed a paste which appeared to be identical in both clay and temper to that of authentic Moche pieces. The fineline drawing was very competent, with a normal line width and appropriate use of design field. Indeed, everything about the piece would argue for its authenticity. Everything, that is, except the iconography of the complex scene used to decorate the chamber.

It is fortuitous that at the time I first saw the bottle I was completing an extensive study of the Presentation Theme in Moche iconography, for the features that most clearly identify this bottle as a fake are largely due to the artist's ignorance of the basic elements of the Presentation Theme. A detailed account of the Presentation Theme in Moche iconography has since been published (Donnan 1975; 1976: 117–129; 1978: 158–173). Suffice it to say here, that it is one of the basic themes, or activities, illustrated in Moche art. It involves the ritual presentation of goblets. The contents of the goblets are not known, but they may, in part, be human blood taken from prisoners who are normally shown in the same scene. To illustrate the Presentation Theme, two examples created by two different Moche artists are shown in Figures 2 and 3. The first (Fig. 2) is a very complex

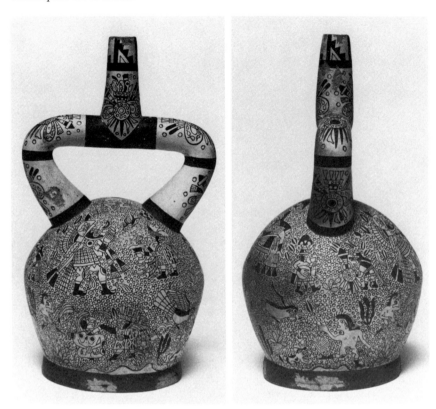

Fig. 1 Fake ceramic bottle. Photographs courtesy of Justin Kerr.

example, drawn on the chamber of a stirrup spout bottle in the Museum für Völkerkunde in Munich. The drawing was first published by Gerdt Kutscher in 1950 (Fig. 62) and subsequently republished by him in 1955 (pp. 24–25). As will be demonstrated in detail below, the published drawing of this piece was of major importance in the production of the fake.

The second example of the Presentation Theme (Fig. 3) is a more simplified version with fewer of the characteristic figures and objects. It is derived from the chamber of a stirrup spout bottle in the Museo Nacional de Antropología y Arqueología in Lima. Comparing it to the scene from the Munich bottle demonstrates the consistency with which Moche artists rendered details of the costumes and ceremonial paraphernalia used in the Presentation Theme.

To facilitate identification, each of the symbolic elements in Figures 2 and 3 is identified with the following letters:

A. A figure with rays emanating from his head and shoulders, a conical helmet and a backflap.

B. A bird figure frequently shown presenting a goblet with one hand while holding a disc with the other.

C. A figure wearing a long shirt and a headdress with tassel ornaments hanging in front and behind. It is important to note that on the Munich bottle the artist, *for lack of space,* has drawn the forward tassel on top of the headdress rather than in front of it (see Fig. 4).

D. A figure with scarflike objects with serrated upper edges hanging from his shoulders. The figure also wears an elaborate nose ornament, and a very characteristic headdress. The front of the headdress has a half circle of sheet metal with an animal face, possibly feline, embossed near its center. This half circle is flanked by two curved objects which are possibly also of sheet metal. At the back of the headdress is a tuft of feathers.

E. A human figure in the process of drawing blood from a bound nude prisoner.

F. A feline figure in the process of drawing blood from a bound nude prisoner.

G. A bound nude prisoner from whom blood is being drawn.

O. A dog.

Q. A fox warrior.

S. A feline warrior.

T. A club and shield.

U. An anthropomorphized club and shield, frequently shown holding a goblet.

W. An ulluchu fruit.

X. A club and shield with feline head.

Y. A seed pod (?).

With this inventory of figures from the Presentation Theme, let us now return to the bottle shown in Figure 1. A simplified rollout drawing of the scene, omitting the circular background filler elements, is shown in Figure 5. Certain figures have been labeled according to the letter designations given above. While figures from the Presentation Theme are clearly recognized in Figure 5, some details of dress and ritual paraphernalia are

Christopher B. Donnan

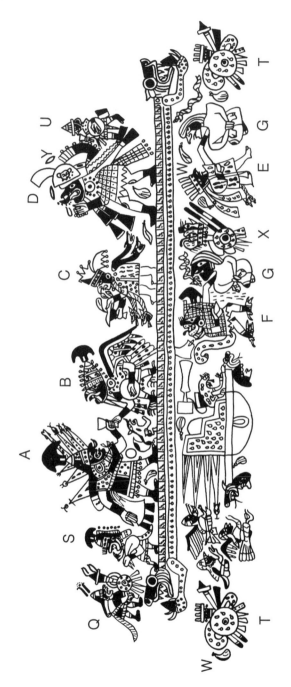

Fig. 2 Fineline drawing from the chamber of a Moche ceramic bottle. Museum für Völkerkunde, Munich (after Kutscher 1950: Fig. 62).

40

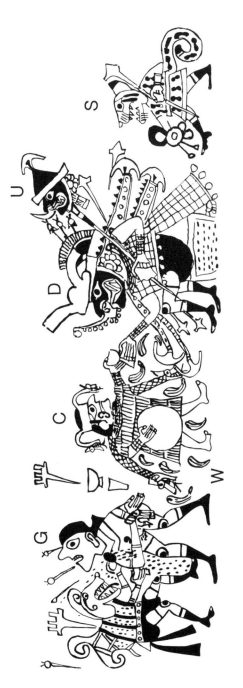

Fig. 3 Fineline drawing from the chamber of a Moche ceramic bottle. Museo Nacional de Antropología y Arqueología, Lima. Drawing by Donna McClelland.

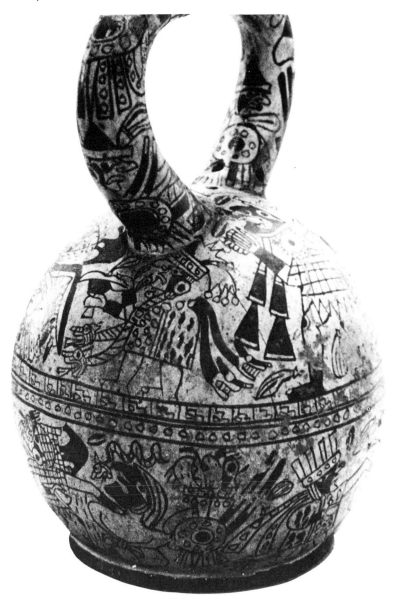

Fig. 4 Detail of Moche ceramic bottle showing position of figure C. Museum für Völkerkunde, Munich. Photograph by the author.

Fig. 5 Fineline drawing from the chamber of fake ceramic bottle. Drawing by Donna McClelland.

strangely aberrant, as though the artist did not really understand what he was depicting. This was evident during a preliminary examination of the scene. The first clear indication that the bottle was a fake, however, was the headdress on figure c. As noted above, the headdress worn by this figure should have tassel ornaments hanging in front and behind. The only known exception is the Munich bottle (Fig. 2). Here the artist drew figure c too close to where the stirrup spout attaches to the chamber of the bottle, and thus did not have room to draw the front tassel hanging forward (Fig. 4). He adjusted to the lack of space by putting the tassel on top of the headdress. In the case of the fake bottle, however, there was ample room in front of figure c to have the tassel hang forward (see Fig. 1), yet the artist drew the headdress with one tassel on top. This immediately suggested that the artist had copied the figure from a published drawing of the Munich bottle, not knowing about the space problem faced by the original Moche artist.

With this in mind, we turned immediately to the published drawings of the Munich bottle, and in so doing located the major key in unraveling the nature of the fake itself. The similarity in the representation of figure c, including the aberrant tassel position, makes a convincing argument that this was the source of the faker's inspiration. This becomes even more obvious when one compares other figures found in the two drawings. Figures A, E, F, and S in Figure 5 are essentially the same as shown in Figure 2, with only a few details altered. The only significant change is that they are turned to face in the opposite direction from the way they are shown in Figure 2. The same is true with most, though not all of the depictions of the ulluchu fruit (w).

Figures B and D are also turned in the opposite direction from the way they are shown in Figure 2. However, in copying these figures the faker also committed some subtle but significant errors. These errors resulted from his ignorance of what the Moche artist was representing. The headdress on figure D, as noted above, is characterized by two curved objects which flank the half disc in the center. In Figure 2 these curved objects are undecorated, one rising up to the left, while the other extends down to the right. The faker apparently misinterpreted the one extending downward, erroneously thinking that it was part of the tuft of feathers at the back of the headdress. As a result, he provided his figure D with a headdress containing only one tassel, rising upward and elaborately decorated, while the second was mistakenly integrated into his depiction of the tuft of feathers.

A similar error was committed by the faker in copying figure B. The dark trapezoidal area at the upper left of the disc held by figure B (Fig. 2) is part of a tunic. However, the faker apparently thought that it was a jar neck, and that the disc was actually the chamber of the jar. He thus drew figure B holding a large jar, presumably meant to contain the liquid being served in the goblet presented to figure A. By way of embellishing on this interpretation, the faker even decorated the chamber of the jar with a geometric design!

In copying figure U from the original, he continued with his idea of jars. It is curious to see how he altered the circular shield and tied sash in the original drawing (Fig. 2) to become a jar and jar neck in his copy (Fig. 5). Actually he copied this figure twice, one figure facing right and one facing left. The one facing right has a crescent in his helmet, and appears to be spilling something from the jar—a detail again erroneously derived from the original.

Another, though even more subtle, error was committed by the faker in copying the dog. Apparently he decided to have three dogs rather than only one. Yet in no Moche depiction of the Presentation Theme is more than one dog shown. Moreover, Moche artists consistently place the dog adjacent to figure A, as though he were a companion of this individual. On the fake, two of the dogs appear to be running after individuals near the bottom of the scene, clearly away from any proximity to figure A.

Finally, the two bound nude prisoners (G) have been copied facing in the opposite direction from their originals. But they have been embellished with shoulder spots, elbow spots, and breast markings, none of which are found in Moche art.

There are two other features which were clearly borrowed from the Munich bottle. These are the club and shield designs T and x, which were used by the faker to decorate the spout on his bottle (Fig. 1).

This list of figures and objects derived from the Munich bottle accounted for most of the elements on the fake piece. There were, however, some features that clearly must have come from other sources. Since the faker relied so heavily on one published Moche drawing for some of his prototypes, it was possible that he obtained the remaining figures and objects from other published sources. A brief search of the major publications containing Moche drawings confirmed this suspicion—the other aspects of the fake drawing were clearly derived from two other Kutscher illustrations (Figs. 6, 7). Figure 6, which provided

Fig. 6 Fineline drawing from chamber of a Moche ceramic bottle. Museum für Völkerkunde, Berlin (after Kutscher 1954: Fig. 8A).

the prototype for the two large birds in Figure 5, was published by Kutscher in 1954 (his Fig. 8A).

Figure 7 was published three times by Kutscher (1950: Fig. 25; 1954: Fig. 24; 1955: frontispiece). It provides the prototype for nearly all the remaining figures and objects on the fake bottle. The scene decorates the interior rim of a flaring bowl in the Museum für Völkerkunde in Berlin. It depicts an arraignment of nude prisoners with ropes around their necks. The captors hold the ropes, while the prisoners' clothing and weapons are tied in a bundle to the captors' war clubs. Blood flows from the noses of the prisoners—apparently the result of combat wounds. It is easy to recognize these individuals as the prototypes of the four nude running figures seen in the lower part of Figure 5. Torn from their original context, however, and drawn without captors, without neck ropes, and without blood flowing from their noses, the figures appear to be blithely running along without clothing, waving at one another! Strangest of all is the figure positioned between the two spouts on the upper part of the chamber. Quite clearly a female, she has no direct parallel either in Figure 7 or any other Moche depiction. The plants and small birds on the fake bottle are strikingly similar to those in Figure 7. It is likely that they were also derived from this source.

There is one other detail for which no known Moche prototype exists. It is quite small, and could easily be overlooked in the field of small filler elements that surround the major figures. It is located near the base of one of the spouts, unobtrusively out of the central design field. It is a circle with a curved line inside separating a light from a dark field (Fig. 5, upper left). Although this design element is not known in New World iconography, it has a long history of use in Asia. In Chinese art it is called *yang-yin*,

Fig. 7 Fineline drawing from Moche ceramic bowl. Museum für Völkerkunde, Berlin (after Kutscher 1954: Fig. 24).

and symbolizes the dual principle in nature (Seyssel 1949). Perhaps this symbol had some special significance to the faker.

It should be noted that the faker, in combining parts from three distinct Moche drawings, created an unlikely hybrid. In Moche art, the Presentation Theme does not take place in a setting of desert terrain. Rather it seems to occur in a setting of religious architecture or in a supernatural realm. Thus the juxtaposition with cacti and undulating sand dunes on this fake is totally inappropriate. Moreover, the large bird derived from Figure 6 is not appropriate to either the Presentation Theme or the arraignment of prisoners.

In essence, this fake bottle is superbly crafted in the Moche tradition, and would be exceedingly difficult, if not impossible, to identify as fake were it not for errors of iconography.[1] These errors are threefold. First, certain elements were inaccurately copied because the artist misinterpreted the original. Thus he created things that never existed, such as the head-dresses on figures C and D and the jars in the hands of figures B and U. Second, in taking elements out of their original context and simplifying them, he created totally inappropriate elements such as the nude figures who run waving to one another along the base of the bottle. Third, by combining parts of different scenes the artist juxtaposed activities and settings that never occurred together in the Moche world.

In June 1978, I had the pleasure of examining the Munich bottle first hand. We were preparing an exhibition of Moche art at UCLA, and the Museum für Völkerkunde in Munich kindly agreed to loan the bottle for the exhibition. There was one aspect of the design on the Munich bottle that had puzzled us for several years—the object above the head of the fox warrier (Q) in the upper left side of the scene (Fig. 2). The two lines that parallel one another and subsequently curve outward abruptly at the upper end seemed to be unique in Moche fineline drawing. Close examination of the Munich bottle revealed that this was not part of the original depiction, but had been added in modern time in retouching a recent repair. The

[1] With the compelling iconographic evidence that the bottle was a fake, we considered the possibility of having it dated by the thermoluminescence method. This process assesses the amount of time that has elapsed since the object was fired—essentially how many years since it was brought up to firing temperature. Unfortunately, the art dealer who owned the piece had had it refired in New York in order to reduce the amount of grey fire clouding on one side of the chamber. While this was partially successful in reducing the grey area, it eliminated the possibility of proving through thermoluminescence that the piece was of modern manufacture.

retouching was subsequently incorporated into the rollout drawing pub-
lished by Kutscher. This feature appears twice on the fake bottle (Fig. 5),
once above the fox warrior (Q) and once above the anthropomorphized
club and shield·(U), thus clearly indicating that the painting is modern, and
almost certainly derived from Kutscher's published drawing.

It is unfortunate that modern craftsmen have so fully perfected the tech-
nology of Moche pottery that they can create replicas of sufficient quality
to make it nearly impossible to distinguish fakes from authentic pieces on
cursory examination. This will certainly make the task of authentication
much more difficult than it has been in the past. On the other hand, there
is some satisfaction in realizing that excellent fakes can be identified
through careful analysis of their iconography. Of course, the fakers may
eventually master the iconographic aspects of the ancient style as well, and
scholars studying iconography will likely be unwilling accomplices by
publishing their insights. Nevertheless, there is some consolation in know-
ing that current research is making us increasingly aware of the structure
and patterning of Moche iconography. Evidence of this is not only in our
ability to say that this particular piece is a fake, but also in our ability to
say why, and even what would have to be different for it to be authentic.

I last saw the fake bottle in 1975. The art dealer who had it in his
possession subsequently returned it to the individual who sold it to him,
along with my judgement of its authenticity. I am told that the bottle was
then taken to Europe, where various people agreed that my judgement
was absurd, and that it must certainly be authentic. As far as I know it is
still for sale. Caveat emptor!

ACKNOWLEDGMENTS I would like to express my appreciation to Donna
McClelland and Alana Cordy-Collins for their help in factoring out the
nature of this fake; and to Donna McClelland, Justin Kerr, and Robert
Woolard for their help in the illustrations.

Christopher B. Donnan

BIBLIOGRAPHY

DONNAN, CHRISTOPHER B.
- 1975 The Thematic Approach to Moche Iconography. *Journal of Latin American Lore* 1 (2): 147–162.
- 1976 *Moche Art and Iconography*. University of California Latin American Center, Los Angeles.
- 1978 *Moche Art of Peru*. University of California, Museum of Cultural History, Los Angeles.

KUTSCHER, GERDT
- 1950 *Chimu, Eine altindianische Hochkultur*. Gebr. Mann, Berlin.
- 1954 *Nordperuanische Keramik*. Gebr. Mann, Berlin.
- 1955 *Arte antiguo de la costa norte del Peru*. Gebr. Mann, Berlin.

SEYSSEL, FRANCES HAWLEY
- 1949 Chinese Art Symbols. In *Chinese Folk Designs* (by W. M. Hawley). Dover Publications, New York.

POSTSCRIPT. While in Peru in July 1982 I finally located the man who had produced this bottle. Thus I am able to add the following information:

1) The artist made the bottle sometime between 1970 and 1972, when he was a young man studying at a local art school. He produced four or five other Moche bottles at that time—the others depict a Moche V maritime scene. He has not produced similar bottles since 1972.

2) He obtained the paste clay from a clay deposit near the lower Moche River. He purchased the white slip clay in Lima. The iron oxide for the red slip came from the upper part of the Viru Valley.

3) His inspiration for the fineline drawing was precisely the illustration published in the books specified above. He did not own these books but used copies from the library at the University of Trujillo.

4) He traced the drawings from the books using tracing paper and pencil. I was able to examine these tracings and found that they incorporate nearly all of the iconographic errors discussed above.

5) The figures on the bottle are reversed from the way they face in the published drawings because he turned the tracing paper over and copied his tracings from the back side. He felt it would be more interesting for him to paint them if they were not an exact copy of the original. This was

continued on page 142

50

A Counterfeit Moche-Recuay Vessel and Its Origins

RAPHAEL X. REICHERT

CALIFORNIA STATE UNIVERSITY AT FRESNO

IN 1977 I WAS ASKED to write an article on counterfeit Recuay ceramics for a Pre-Columbian art history anthology (Reichert 1977). Because of the limited amount of lead time for that work I focused on counterfeit vessels that had already been illustrated in the literature yet had not previously been identified as fraudulent—those that had thus contaminated the most readily available sample of Recuay vessels. The vessels dealt with in 1977 formed a special category consisting of legitimate Recuay vessels or fragments which had been reconstructed incorrectly. The present work is meant to be an extension of the 1977 publication but with a shift to a specimen that is completely fraudulent and is also as yet unpublished. The function of this effort is thus intended not only to be informative, but also preventive in terms of dealing with the products of the counterfeiter's trade.

One of the fascinating aspects of analyzing counterfeit specimens lies in attempting to determine the forger's source of inspiration. In some instances the counterfeit deviates so markedly from all authentic pieces that its genesis must have been largely in the potter's mind. In these cases the forger presumably gambles that he will find a buyer anxious to own a "one-of-a-kind," and possibly someone willing to spend extra money to get it. These extravagant vessels are, however, the exception rather than the rule. Normally, it appears that the forger is trying to recreate a known piece or type; he believes his key to success is in duplication rather than elaboration. When the skilled forger copies authentic pieces exhibited in museums or in the literature, his work can be extremely convincing. Sometimes, however, he inadvertently copies specimens that have been incorrectly reconstructed or inaccurately illustrated. Such choices can ultimately serve to expose the counterfeit work. This paper will examine an

authentic Pre-Columbian vessel, a published drawing of the vessel, and the counterfeit that resulted from the drawing.

The counterfeit (Fig. 1) is from a private collection and was first brought to my attention in 1977 when I was sent photographs of the Recuay material from the collection. I contacted the owner, requesting permission to document a piece that seemed unusual, and was immediately invited to do so. The owner expressed concern that the unique piece might prove to be a forgery. As will be seen, his fear was well founded.

Figure 1 illustrates an 18.2 cm. high, flat-topped, circular chambered vessel with six modeled figures on top: a large central human, four smaller attendant humans, and an animal head. A flaring spout projects up from behind the central figure. The painting on the vessel is a cream slip over which a reddish-brown slip has been applied. The dark slip is used for decorative and anatomical features on the modeled figures as well as for representing crested profile animals around the vessel chamber. Specific features of this vessel, appropriate to this discussion, will be examined in detail later.

The following discussion will attempt to demonstrate not only that the vessel is a modern counterfeit, but that it was indirectly inspired by a specimen from the Linden-Museum in Stuttgart (Fig. 2). In order to trace the ancestry of the counterfeit one must begin with a description of the Stuttgart vessel.

The Stuttgart vessel (No. 93563) is 27 cm. high with a circular chamber, domed top, large flaring spout, and six figures modeled on the chamber top (Fig. 2). Its configuration is, in gross terms, the same as the counterfeit. At first glance the Stuttgart vessel appears to be a Recuay vessel of the type designated as J by Bennett (1944: 102) and later reclassified by Reichert (n.d.c: 133–138) as j^1. A closer examination, however, suggests that the vessel should probably be labeled Moche-Recuay. The form as well as figure placement is certainly Recuay derived. The vessel height (a third larger than the mean for this Recuay type), the very large flaring chamber spout, and the distinctive chamber paint (an apparent attempt to emulate Recuay three-color resist) are all features suggestive of the work of a Moche artist inspired by a Recuay model. Although such hybrid vessels have been discussed previously (Reichert n.d.a, n.d.b), they have yet to be analyzed in the literature.

That the Stuttgart vessel was possibly created by a Moche artist influenced by a Recuay prototype is suggested by the painting, particularly that

of the chamber sides. The painting on the vessel is a positive application of what appear to be three slip colors.[1] The vessel is covered with a light cream or white slip over which are applied two shades of a dark, probably reddish, slip. The dark slip is used for some of the figures' anatomical features as well as details of clothing and other personal accouterments. The painting on the walls of the chamber, as indicated above, deserves special comment. It appears that once the chamber was painted with light slip, its sides were then over-painted with the lighter of the two dark slips. This over-paint is used for a series of nearly square registers painted around the chamber. The same color was used for parallel framing bands above and below the registers. After the application of the dark registers the artist then returned to cream slip and in each register painted a profile animal with cephalic crest. The final painting step involved filling the bodies of the animals with details, using both shades of dark slip. The darkest slip was used for the interior crest lines, muzzle bands, certain torso details and also as a vertical band between registers. Above all, it is important to note that although the profile animals might appear to have been painted using a resist technique, close examination indicates that this was not the case.

The modeled figures on the Stuttgart vessel include a large central figure holding a bowl that is tilted slightly outward. Only the arm holding the cup is modeled, the other is simply painted. This is in keeping with a practice not uncommon in Pre-Columbian Peruvian art, specifically, the de-emphasis of arms that are inactive—that are neither holding an object nor gesturing. This figure wears an "earred" headdress from the front of which projects a truncated conical form. On many Recuay vessels this headdress form would be a spout (cf. Kubler 1962: Pl. 128A); here, however, the end of the projection is capped and incised with lines. The figure's only other adornment is a pair of earspools, each painted with a cross and four dots, and a simple garment with parallel straight and wavy lines on its front.

Four human attendant figures, each approximately one-half the height of the central figure, flank that figure. Two stand on each side of the vessel top facing forward. These attendant figures wear short cowls, garments decorated with stripes and dots, and most importantly, hold distinctive objects in front of them. The held objects are approximately oval or celt

[1]Since I have only had access to black-and-white photographs of the Stuttgart vessel, its color description is to be read in terms of relative value only.

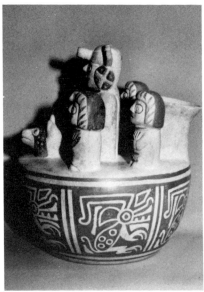
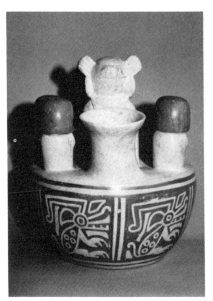

Fig. 1 Moche-Recuay style jar (counterfeit). Height 18.2 cm. Private collection.

A Counterfeit Moche-Recuay Vessel

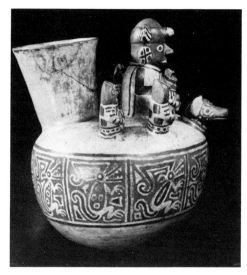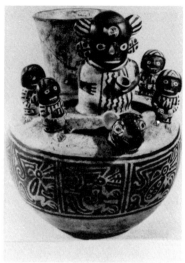

Fig. 2 (*above*) Moche-Recuay style jar. Height 27 cm. Linden-Museum, Stuttgart (No. 93563). Left photograph courtesy Christopher B. Donnan, right photograph courtesy Linden-Museum (see also Anton 1962: Pl. 12).

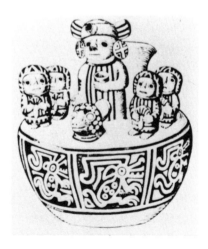

Fig. 3 (*right*) Drawing of the Linden-Museum vessel (after Carrion Cachot 1955: Pl. XVI).

shaped, and are painted with light slip. Over the light color a dark slip is used to paint a horizontal stripe to which vertical parallel lines run perpendicular. It is important to note that the objects are meant to be seen as separate units held by the figures, and that the painted vertical parallel stripes are themselves parallel to the longitudinal axis of each oval. The identity of these objects is uncertain, but they may represent highly stylized human hands. Other examples of human anatomical parts are well documented from both the Moche and Recuay styles.

The last modeled feature on the Stuttgart vessel is an animal head, possibly a llama, that projects from the chamber top immediately in front of the central figure. This head is predominantly dark with light ears, and eye and neck rings. The head also appears to have been covered with light dots that were then over-painted with a wash of the darker slip. Like the chamber painting, this over-paint treatment of the llama head may have been an attempt to capture the effect of Recuay three-color resist, without a knowledge of the actual technique.

In 1955, Carrion Cachot published a series of drawings of Peruvian ceramics from European and Peruvian collections. One of these illustrations (Fig. 3) is of particular interest since, although it is only casually and, in fact, incorrectly identified by Carrion Cachot,[2] it is clearly based on Stuttgart No. 93563. Unfortunately, the drawing (hereinafter referred to as the Carrion Cachot drawing), like the attribution, is inaccurate. It would appear that the artist responsible for the Carrion Cachot drawing was familiar with the Recuay style but probably not aware of the Moche elements in the vessel. This seems likely because of the treatment of the chamber spout which, as drawn, is closer to a Recuay type (cf. Fig. 4) than to the one on the Stuttgart vessel. In addition, although the central figure's headdress on the Stuttgart vessel has a sealed tubular projection, on the Carrion Cachot drawing this is depicted as a small spout. Headdress spouts are common on Recuay vessels but rare, if in fact they occur at all, on purely Moche specimens.

The most damning and, at the same time, most intriguing features of the faulty drawing are the objects held by the four small attendant figures. It appears that the artist was trying to depict each figure as holding a fan. The fact that the lines on the upper part of each object do radiate outward

[2]Carrion Cachot (1955: 69) identifies this vessel simply as "Colec. Macedo, Alemania." Dr. Schulze-Thulin of the Linden-Museum recently informed me that No. 93563 is from the Sutorius collection. No further details were available regarding its origin.

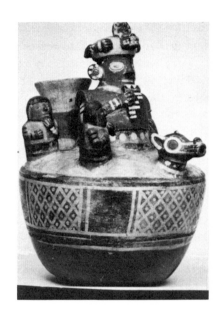

Fig. 4 Recuay jar. Height 23.1 cm. Danish National Museum, Copenhagen (No. J5163, d223). Photograph courtesy of the Danish National Museum.

would seem to support this contention. If this identification is correct, then the objects are meant to be read as circular or semicircular fans which are being held at their lower, outer edges with the handle hanging downward. It is important to emphasize that these lines are not parallel in the drawing although they are on the original vessel.

I know of no Pre-Columbian fans associated with Recuay or Moche remains. However, the National Museum of Anthropology and Archaeology in Lima does exhibit fans with a south coast provenance. It is possible that the creator of the Carrion Cachot drawing was familiar with such fans.

Although I believe the artist did indeed intend to depict fans in the attendants' hands, I do not think that anyone unfamiliar with the art and other material culture of Pre-Columbian Peru would immediately or necessarily see the objects as fans. This is due to the ambiguities within the drawing. First, if one compares the lines on the tops of the fans with those on the chest area of the figures, it is seen that the width and spacing of these lines is virtually identical in both areas. To a viewer not prepared to see fans, the figures could be read as holding up a folded piece of their garments.

Having already influenced the reader's perception of the held objects by referring to them as fans, the next ambiguity might be difficult to eluci-

date. I refer specifically to the zones between the figures' hands, zones that were probably intended to represent the fan handles. If one approaches the drawing with a mind-set that expects fans, then handles can be readily perceived. If, however, one is not biased by a specific identification for the objects, then it would be difficult to relate the striped arc extending up from the figures' hands with the zone between and below their hands. More to the point, it becomes difficult to determine if these lower areas are meant to be convex or concave, an ambiguity that led, as we shall see, to an interesting misinterpretation.

Another ambiguous feature of the drawing occurs in the rendering of the chamber top. The impression created by the drawing is that the vessel top is flat. This is caused by the lack of shading over the majority of the visible surface. The viewer who closely scrutinizes the drawing can only be confused by the concentric curved lines on the far right. Do they represent a figure's shadow or the edge of a convex top? We cannot tell.

The final feature to be pointed out in the drawing is the right hand of the central figure which, unlike the sculpted left hand, is only painted. Because of the angle from which the vessel was drawn only a small portion of the painted hand appears in the drawing. Without a thorough knowledge of Pre-Columbian Peruvian artistic canons, it seems unlikely that anyone would read the dark lines on the side of the figure's garment as fingers.

Given the discrepancies between the Stuttgart vessel and the Carrion Cachot drawing, one could legitimately ask if the latter might not possibly refer to another vessel from a German collection. That question can be answered by a careful comparison of the design details within the two chamber registers immediately beneath the animal head. Such a comparison leaves no doubt that the Carrion Cachot drawing is indeed simply a poor rendering of the Stuttgart vessel. Exactly how this transformation occurred is unclear but it seems probable that either the drawing was made in haste from the actual specimen, or, more likely, that it is based on poor photographs of the Stuttgart vessel with the draftsman simply guessing about those portions that were unclear.

A comparison of the counterfeit vessel (Fig. 1) with the Carrion Cachot drawing (Fig. 3) should make it clear that the forger worked directly from the drawing and never saw the Stuttgart original. The drawing, however, provided more than inspiration to the forger. In addition to misleading through blatant inaccuracies, the drawing's lack of clarity required that the

counterfeiter compensate in a number of areas. It was pointed out above that the drawing misrepresented the original by placing a spout on the central figure's headdress, by reducing the size of the chamber spout, and by making the chamber top appear flat. These features were faithfully reproduced on a counterfeit vessel of basically the same format as the Stuttgart original. But from this point on the counterfeit takes on special characteristics of its own.

Two particular features are notable. The first concerns the central figure. Unable to interpret the black lines on the garment as a hand, and not seeing a modeled arm, the counterfeiter chose to eliminate that limb altogether. He did, however, represent the figure's garment in such a way that the viewer could infer that the missing arm was beneath the textile. The second feature is the objects held by the attendants. In this instance, the counterfeiter responded to the ambiguity of the Carrion Cachot drawing by creating an ambiguity of his own. Most conspicuously, he interpreted the "fan handle" of the drawing as a concave element and rendered it as a shallow incision on the front of the figures. This incision invites a number of possible interpretations including a possible reference to enlarged genitalia. The reason a forger would produce specimens with sexual overtones is clear; such pieces are in demand and sell well. Here it is worth noting that in careful examination of large samples of Pre-Columbian Peruvian vessels, it was found that less than one percent of the specimens had any blatant sexual references. In contrast to this, in a recent auction catalogue (Sotheby Park Bernet, May 26, 1978), of twenty-four Peruvian vessels illustrated, six, or twenty-five percent, depicted sex organs or acts.

After conducting the initial research on the counterfeit vessel, I recalled that Professor James Kus had a small collection of reproductions of Pre-Columbian Peruvian vessels. I had never given much attention to contemporary Peruvian products designed for the tourist market, but with the hope of finding some leads to the creator of the counterfeit, I decided to take a close look at Kus's collection.

This proved fruitful because among Kus's vessels was a virtual twin to the counterfeit. According to Kus, this piece was the work of a potter named Alejandro Vélez Abanto, who had a large workshop in Cajamarca. The Kus vessel (Fig. 5), however, although unmistakably made by the same hand that created the counterfeit, was not itself a forgery. Stamped on its bottom are the words, "Reproducción. Hecho a mano. PERU." There is no such inscription on the bottom of the counterfeit.

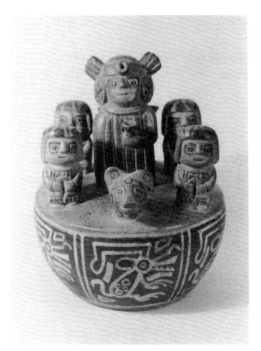

Fig. 5 Moche-Recuay style jar (reproduction). Mate to Figure 1 specimen. Height 17.3 cm. Collection Dr. James Kus. Photograph by Michael Tilden.

One must conclude therefore, that the counterfeit was created in one of two ways. First, it is possible that the Cajamarca shop has two lines of production; some vessels receive identifying stamps, others do not. Alternatively, an unscrupulous individual purchased the reproduction, carefully filled in the stamped letters, and then retouched the altered surface.

A frequently voiced concern regarding publications on counterfeiting is that they have the potential of better arming the counterfeiter by educating him about flaws in his previous work. Thus, it may be argued, the forger and scholar work as a team whose mutual efforts can lead to new generations of counterfeits of increasing sophistication.

Ten years ago this objection was a valid one. Today, however at least for the Recuay and Moche styles, the situation has changed. Because of the creation of two photographic archives, Donnan's for Moche and mine for Recuay, scholars now have excellent tools with which to combat forgers. The great number of stylistic and iconographic variables inherent in Moche and Recuay pottery make it extremely unlikely that every facet of the counterfeiter's work will pass comparison with 7000-plus samples of Moche pottery and 1000-plus of Recuay.

In terms of the present work the reader might wonder how many more of Carrion Cachot's, or other representations in the literature, are inaccurate. Suffice it to say that the deck is yet to be completely dealt.

Raphael X. Reichert

BIBLIOGRAPHY

Anton, Ferdinand
 1962 *Alt Peru und seine Kunst*. E.A. Seeman Verlag, Leipzig.

Bennett, Wendell C.
 1944 The North Highlands of Peru, Excavations in the Callejon de Huay-
 las and at Chavin de Huantar, *Anthropological Papers of the American
 Museum of Natural History*, 39, Pt. 1. New York.

Carrion Cachot, Rebeca
 1955 El culto al agua en el antiguo Peru. Separata de la *Revista del Museo
 Nacional de Antropología y Arqueología* 2 (2). Lima.

Kubler, George
 1962 *The Art and Architecture of Ancient America*. Penguin Books, Balti-
 more.

Reichert, Raphael X.
 1977 Pre-Columbian Ceramics: The Problem of Partial Counterfeits. In
 Pre-Columbian Art History—Selected Readings (Alana Cordy-Collins
 and Jean Stern, eds.) Peek Publications, Palo Alto.
 n.d.a Moche Imitations of Recuay Ceramics. Paper presented at the 13th
 Annual Meeting of the Institute of Andean Studies, Berkeley, 1973.
 n.d.b Moche-Recuay Relationships: The Ceramic Evidence. Paper pre-
 sented at the Annual Meeting of the Pacific Coast Council on Latin
 American Studies, San Diego, 1973.
 n.d.c The Recuay Ceramic Style—A Re-evaluation. PhD dissertation. Uni-
 versity of California, Los Angeles, 1977. University Microfilms, Ann
 Arbor.

On Faked Peruvian Silver Head Jars Distributed as Pre-Columbian

S. HENRY WASSÉN

GOTHENBURG ETHNOGRAPHIC MUSEUM

I N 1935 THE GOTHENBURG ETHNOGRAPHIC MUSEUM received a silver head jar (Fig. 1) from a private donor living in Lima, Peru. The head was said to be a Pre-Columbian product. A young ethnographer on the staff made a drawing of the head which he placed in the card index file with the following description (most likely derived from the donor): "Metal vessel, in the form of a human head. Said to have been stolen from the Presidential Palace of Lima, when plundering took place during a revolution." A full description was not presented, but as can be seen from the photographs in Figure 1, the head is a stirrup spout jar, with a trephining scar on the skullcap as one of its most salient features. The jar was on exhibition in the museum for some years, but doubts of its authenticity arose, and it was placed in storage.

In 1958, following a series of investigations into Peruvian silver vessels, I added a note to the same catalogue card: "Not an Indian specimen." This notation was added after Luciano Herrera from Lima visited the museum on March 10, 1958, and informed me that such heads had been produced and sold in recent years, especially at Ayacucho.

My study of Peruvian silver vessels had begun some years earlier, when, on October 9, 1955, our late colleague Samuel K. Lothrop wrote to me about the Gothenburg vessel:

> I think your silver head is genuine. It probably is part of a group [from one grave?] acquired by —— [name omitted]. Two of these were purchased by a dealer named —— [name omitted]. One, published by Kelemen is now in the Cleveland Art Museum. The other came to this museum in an exchange. I will send

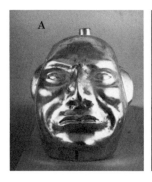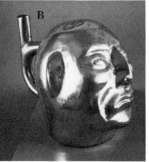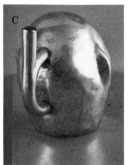

Fig. 1 Three views of the silver effigy head in the Gothenburg Ethnographic Museum. Cat. 35.32.45. Height 19 cm. Photograph courtesy of the Gothenburg Ethnographic Museum.

you a photograph. The soldering technique is very early in Peru and goes back to Cupisnique, also the use of silver. I have published a Mochica silver figurine which employs solder (Lothrop 1951: Fig. 80).

Following Lothrop's leads, I began to investigate these and other Peruvian silver effigy vessels. In 1956 I submitted a series of silver objects to the laboratory of the shipbuilding yard Götaverken, in Gothenburg, for metallographic analysis (see Table I), and in 1957 other vessels were analyzed by mining engineer C. G. Carlsson of the Swedish Institute for Metal Research, Stockholm (see Table II).

The silver vessel in the Cleveland Art Museum (Fig. 2A) had been described by Kelemen (1944, I: 244; II: 196b) as a "silver stirrup jar, perhaps from the Mochica culture but with strong Chavín influence," representing "an anthropomorphic jaguar god in the round. About 13 inches high and hammered of highgrade metal, it was made in several parts and soldered together." Kelemen had thus accepted this jar as genuine. The vessel had previously belonged to John Wise of New York and had been exhibited at the Wadsworth Atheneum in 1937 along with four other silver Peruvian vessels in the Wise collection (Bennett 1937: No. 27). There are no archaeological records about the Cleveland vessel, and although I have seen no spectrographic data on it, I consider the jar to be a modern creation; its prototype was probably similar to the pottery vessel from the Chavín-Costeño culture now housed in the Ethnographic Museum of Munich and published by Heinrich Ubbelohde-Doering (1952: Pl. 235) (see Fig. 2B).

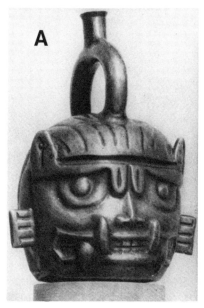
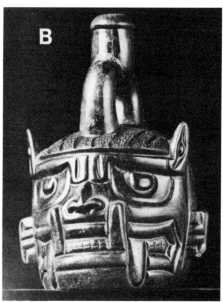

Fig. 2 (A) Silver stirrup vessel in the Cleveland Museum of Art. Height *ca.* 33 cm. (after Kelemen 1944: Pl. 196*b*). (B) Ceramic vessel of the Chavín-Costeño style in the Museum für Völkerkunde, Munich. Height 21 cm. (after Ubbelohde-Doering 1952: Pl. 235).

The effigy vessel in the Peabody Museum, mentioned by Lothrop, is seen in Figure 3. Like the Cleveland piece, it was among the Peruvian "silver huacos" in the Wise collection exhibited at the Wadsworth Atheneum (Bennett 1937: No. 29). Wendell C. Bennett (1954: Fig. 47) later described the vessel as a: "stirrup-spout jar, representing the mutilated head of a felon with feline heads on his headdress. Mochica. Hammered silver."

Four other silver vessels had come to my attention in 1955 when a friend in Lima deposited them in the Gothenburg Ethnographic Museum (Fig. 4). These were known to be of modern manufacture, however, and they were later reclaimed by the owner.[1] A year later another similar jar was added to the sample. During the 5th International Congress of Ethnology

[1] I did not know of the fate of these four vessels until 1978. During the Dumbarton Oaks conference (October 1978), Junius B. Bird of the American Museum of Natural History had a surprise for me; he had brought with him two of these vessels (Figs. 4C, D), which he had on loan from their present owners in New York. Thus, at least two of the four are still potentially "on the market."

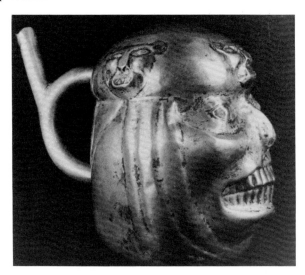

Fig. 3 Silver stirrup spout vessel in the Peabody Museum, Harvard University, Cambridge. Cat. 52-30-30/7347. Height 18 cm. Photograph courtesy of the Peabody Museum.

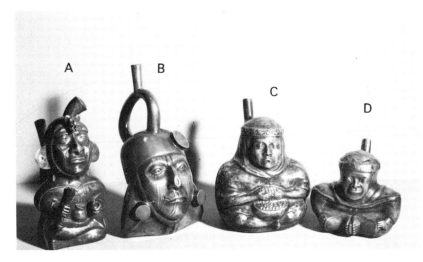

Fig. 4 Four silver effigy vessels from Peru, deposited in 1955 in the Gothenburg Ethnographic Museum and later reclaimed by the owner. Photograph courtesy of the Gothenburg Ethnographic Museum.

held in Philadelphia in 1956, I was able to see the silver effigy vessel in the University Museum of the University of Pennsylvania (Fig. 5), which had been catalogued by Alfred Kidder II as "Peru, North Coast, Mochica, c. 1st century A.D."

<div align="center">TRACE ELEMENT ANALYSIS</div>

The Gothenburg jar (Fig. 1), the four modern silver vessels (Fig. 4), and one authentic and typical Peruvian silver beaker of the Gothenburg collection (Fig. 6) were submitted to the Götaverken Shipbuilding Laboratory for spectrographic analysis by means of a Hilger-Medium-Spectrograph with a quartz prism. According to the report of November 9, 1956, several metals were identified as being present (see Table I). Traces of silicon (Si) were found only in the vessel of Figure 4A.

The six silver vessels analyzed by the Götaverken Shipbuilding Laboratory, plus two additional silver objects in the Gothenburg Museum, were then taken to the Swedish Metallografiska Institutet for further analysis. The two additional pieces were a second silver beaker, which had been found in the region between Ica and Pisco (Fig. 7), and a silver "top hat" from the Virú Valley, which was said to have been found with a mummy bundle and was in the collection of Erland Nordenskiöld for many years (Fig. 8).

The Swedish Metallografiska Institutet undertook a spectrographic analysis of the eight silver objects. Mining engineer C. G. Carlsson summarized the results in a detailed report of October 10, 1957, which translates as follows:

> The purpose was to compare, with the help of modern metallurgical technology, the supposedly authentic objects with doubtful ones in order to acquire a basis for judging the genuineness. The methods used were a microscopic inspection of the metallic structure, a study of the soldering technique, and a determination of the chemical composition of the metal.
>
> The studies of the structure and soldering technique were considered of no value in this case primarily because, even if the objects were modern, the modern methods of production are practically the same as those in the Pre-Columbian period. On the other hand, Pre-Columbian methods for extracting silver were primitive, so that ancient metals contain different impurities from metals produced in modern times. Thus the various trace

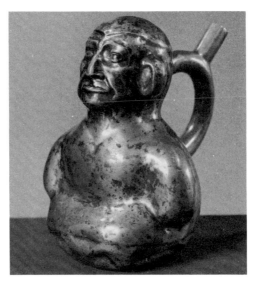

Fig. 5 Silver effigy vessel in the University Museum, University of Pennsylvania, Philadelphia. Cat. 53.51.1. Height 17.5 cm. Photograph courtesy of the University Museum.

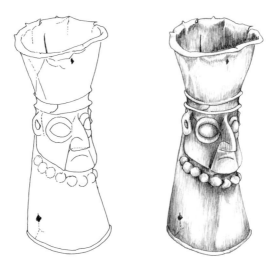

Fig. 6 Silver beaker, Pachacamac. Gothenburg Ethnographic Museum. Cat. 23.5.199. Height 18 cm. Photograph courtesy of the Gothenburg Ethnographic Museum.

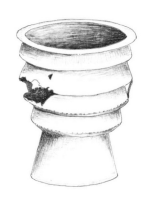

Fig. 7 Silver beaker from the region between Ica and Picso. Gothenburg Ethnographic Museum. Cat. 23.5.160. Height 16 cm. Photograph courtesy of the Gothenburg Ethnographic Museum.

Fig. 8 Silver "top hat" said to have belonged to a mummy bundle, Virú Valley. Gothenburg Ethnographic Museum. Cat. 38.45.197. Height 16 cm. Photograph courtesy of the Gothenburg Ethnographic Museum.

S. Henry Wassén

TABLE I. TRACE ELEMENTS IN THE METALS OF THE VESSELS ILLUSTRATED IN
FIGURES 1, 4A–D, AND 6. ANALYSIS BY THE GÖTAVERKEN SHIPBUILDING
LABORATORY, GOTHENBURG

	Fig. 1	Fig. 4A	Fig. 4B	Fig. 4C	Fig. 4D	Fig. 6
Ag	+	+	+	+	+	+
Cu	+	+	+	+	+	+
Au	+	+	+	−	+	+
Sn	+	+	−	−	−	−
Si	−	+	−	−	−	−
Pb	+	+	+	−	+	+

elements are of interest in this case since they give an identifica-
tion of the silver in relation to its age.

A spectrographic analysis of the silver in the objects has been
carried out in such a way that the trace elements could be deter-
mined. Samples weighing from 3 to 4 mg. were taken. The
samples were placed in hollowed-out carbon electrodes and com-
pletely gasified with the aid of an arc source. The light thus
generated was registered on a quartz spectrograph and the result-
ing spectrogram examined from the standpoint of the appearance
of some twenty elements.

The three objects considered genuine were two beakers with
numbers 23.5.160 and 23.5.199 [Figs. 7, 6], as well as a "hat"
with number 38.45.197 [Fig. 8]. The doubtful objects were one
head with trephining scar number 35.32.45 [Fig. 1], and four
silver vessels numbered A, B, C, and D [Fig. 4].

The investigation has shown that the silver in all the objects
contains a certain amount of copper, the percentage of which
could not be more definitely determined. In regard to the trace
elements, see the table [Table II].

Table II allows one to compare the amounts of an element in the
samples, but it does not show the proportion of the various trace elements
in a single sample. In other words, the designations + + + for gold (Au)
and + + for lead (Pb) in the same sample do *not* imply that the percentage
of gold is higher than the percentage of lead. The last four elements in the

70

TABLE II. TRACE ELEMENTS IN THE METALS OF THE VESSELS ILLUSTRATED IN FIGURES 1, 3, 4A–D, 5, 6, 7, AND 8. ANALYSIS BY THE SWEDISH METALOGRAFISKA INSTITUTET

	Fig.1	Fig.3	Fig.4A	Fig.4B	Fig.4C	Fig.4D	Fig.5	Fig.6	Fig.7	Fig.8
Au	+++	+++	+++	+++	+++	+++	+++	+++	+++	−
Sn	++	++	++	++	++	++	++	−	(+)	−
Pb	++	++	++	++	++	++	++	++	++	++
Sb	(+)	(+)	(+)	(+)	(+)	(+)	(+)	(+)	−	−
Bi	+	+	+	+	+	+	+	+	+	+
Zn	(+)	+++	(+)	+++	+	+++	−	−	(+)	−
Cd	−	−	−	++	−	++	−	−	−	−
Mn	+	−	−	−	−	−	(+)	+	+	++
Fe	++	++	++	++	++	++	++	++	++	++
Cr	−	−	−	−	−	−	−	−	−	−
Ni	+++	+++	++	++	++	+++	++	−	−	−
Co	−	(+)	−	−	−	−	−	−	−	−
Mo	−	−	−	−	−	−	−	−	−	−
V	−	−	−	−	−	−	−	−	−	−
Si	+++	+++	+	+	+	+	+	+++	+	+++
Ti	+	−	+	+	+	+	−	+	+	+
Al	++	+	++	++	++	++	+	++	++	++
Mg	+++	+	+	+	+	+	+	+++	+++	+++
Ca	++	−	−	−	−	−	−	(+)	(+)	+++

Lines of the element:
 −do not appear
 (+)appear very indistinctly
 +appear indistinctly
 ++appear clearly
 +++appear strongly

table (titanium, aluminum, magnesium, calcium—Ti, Al, Mg, Ca) would seem to come from surface impurities. The samples from the "genuine" objects (Figs. 6–8) were much corroded and cracked, and it may be assumed that dust and other impurities have remained in the cracks in spite of cleaning.

It seems that the varying percentages of gold, tin, zinc, cadmium, and nickel (Au, Sn, Zn, Cd, Ni) are the distinguishing features of the silver. The three "genuine" objects (Figs. 6–8) are characterized by the absence of nickel and cadmium (Ni, Cd) and by the absence, or insignificant percentage, of tin and zinc (Sn, Zn). One of them is characterized by the absence of gold (Au) (Fig. 8). The other five specimens are distinguished by the presence of nickel and tin (Ni, Sn). The vessels of Figure 4B, D form a special group by the presence of zinc and cadmium (Zn, Cd).

An analysis has also been made of the solder used for attaching the handle of the Gothenburg effigy vessel (Fig. 1). The main ingredients were silver and copper (Ag, Cu), and the percentage of zinc (Zn) was rather high. The impurities were lead, tin, gold, nickel, bismuth, magnesium, and iron (Pb, Sn, Au, Ni, Bi, Mg, Fe).

Shortly after this analysis was complete, the Metallografiska Institutet analyzed the trace elements of samples taken from the Peabody Museum jar (Fig. 3) and the University Museum vessel (Fig. 5). In his report of November 30, 1957, Carlsson indicated that, as shown in Table II, the trace elements of the Peabody and University Museum objects coincide best with the modern vessels illustrated in Figure 4 (B, D). Regarding the percentage of zinc (Zn) in the Peabody jar (Fig. 3), he suggested that the sample may have been taken near a soldered joint and that the zinc might thus come from the solder. In a letter of February 13, 1958, Carlsson added, in support of my own observation, that the silver head from the University Museum (Fig. 5) and the Gothenburg effigy vessel (Fig. 1) are practically identical in metallic composition, and that both objects probably were made in the same workshop and from the same supply of silver. A verification of their origin from a single workshop and silver supply would rest on a quantitative analysis of their impurities, however, and this laborious procedure was not undertaken.

Following these analyses, S. Landergren reported to the director of the Swedish Geological Survey in Stockholm (December 6, 1957) in support of the possible diagnostic importance of trace metals. He added, however, that it is risky, if not impossible, to make a statement about the origin of the

silver based only on a quantitative spectral analysis of the trace elements, for we have an imperfect knowledge of the distribution of metal elements in the natural supplies of Peruvian and Bolivian silver. The silver in South American silver ores, he continued, can appear in association with gold, tin, zinc, lead, copper, etc.; sometimes silver is found in a relatively pure state, and the percentage of other metals can thus be negligible.

<div align="center">TECHNICAL EXAMINATION</div>

Prior to the trace element analysis, most of the Peruvian silver and copper specimens in the Gothenburg Ethnographic Museum had been handed over to a jeweler in Gothenburg for the mild treatment of washing and removing of the verdigris which in some cases was threatening to ruin the delicate objects. The jeweler was careful to remove only the results of the oxidation process, and he made absolutely no use of sandpaper. I make this remark specifically because the Gothenburg effigy vessel (Fig. 1) had evidently been polished, a process not observed on the authentic silver pieces in the collection. When studied microscopically, the jars B, C, and D of Figure 4 also showed a scratched surface from a polishing process.

A curious observation by the jeweler was that the water from rinsing the Gothenburg effigy vessel turned red, which he believed to have been caused by the presence of blood stains in the vessel's cavity. A more logical explanation was later offered by Thore Eldh, a well-known Gothenburg silver expert, who indicated that a residue of pitch containing a substance that had a strong coloring effect had been left in the head when the skullcap was closed during its manufacture. The jar should therefore be considered as unused, for if it had been used, such a coating on the surface of the interior—left from the chasing process—would not be found.

After Carlsson's trace element analysis of the eight silver objects, I had asked Eldh to come to the museum and discuss the matter of authenticity from his point of view. He paid a visit to the museum on October 29, 1957, and the same day I summarized his statements in a report kept in the museum.

Eldh first inspected the two beakers (Figs. 6, 7) and the "top hat" (Fig. 8), and he found especially the beaker in Figure 7 to be a fine example of skillful craftsmanship, in this case through embossing. A reference to Dudley T. Easby's paper (1955) was made.

The effigy head jar (Fig. 1), Eldh found to have been embossed from

one piece up to the circular skullcap; the handle was made from two halves soldered together, the seams being seen in the interior. The whole vessel thus consists of four parts: the head, the skullcap, and two halves of a handle. Small repairs had been made, for example, on the nose. The so-called trephining mark must have been made before the skullcap was fastened in place. One must consider the whole jar as a piece of excellent craftsmanship. The hardness of the material could be felt immediately, and Eldh pointed out that the presence of nickel makes silver harder and therefore more difficult to emboss.

If a comparison is made between this vessel (Fig. 1) and the four effigy vessels of Figure 4, considerable differences, but also certain likenesses, can be observed. The effigy vessels c and d in Figure 4 must almost certainly have been made by the same person; the handles and the bodies of the two vessels were each made from two halves. Part of the handle of vessel A in Figure 4 was made of bent and soldered sheet-metal, while the other part was made of two halves; the head and the hands were cast. The body of the vessel was made of three parts: two sides and a bottom. The body of vessel B in Figure 4 consists of four parts: the vertical portion of the stirrup spout was made of bent sheet-metal, which was soldered at the front, and the rest of the handle was made of two halves. Among other details, the two ear discs were soldered.

The presence of nickel in the Gothenburg head (Fig. 1) and the four figure vessels (Fig. 4) was considered by Eldh to have a connection with alloying for embossing purposes. He also remarked that zinc was present in the solder for the handle of the jar in Figure 1, and that zinc is used now to facilitate soldering. As zinc seems to be practically missing, or sparsely used, in other Peruvian metal specimens, this argues against the jar's authenticity.

CONCLUSIONS

Judging from the clear statement of the Peruvian visitor regarding the recent production and sale of silver vessels, the results of the trace element analysis and the technical examination, and the fact that no data of archaeological character are known about any of the jars discussed in this paper, we may conclude that the three head jars now in Gothenburg, Cambridge, and Philadelphia (Figs. 1, 3, 5) were all produced in modern times by Peruvian silversmiths. The Cleveland Art Museum silver head published by Kelemen (Fig. 2A) evidently belongs to this same group of

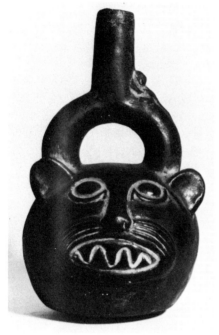 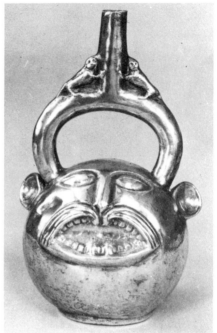

Fig. 9 Ceramic vessel from Lambay-
eque in the Gothenburg Ethnographic
Museum (Gaffron collection). Cat.
22.1.77. Height 20 cm. Photograph
courtesy of the Gothenburg Ethno-
graphic Museum.

Fig. 10 Silver water jar in the Mon-
treal Museum of Fine Arts. Cat.
46.Ds.3. Height 18.5 cm. Photograph
courtesy of the Montreal Museum of
Fine Arts.

vessels recently executed in the Pre-Columbian style. It, like the others,
was produced of several parts that were soldered together. The trephining
mark on the skullcap of the Gothenburg head (Fig. 1) and the feline heads
on the headdress of the Peabody Museum jar (Fig. 3) show the same kind
of inventiveness often demonstrated by fakers. Thus it seems that a num-
ber of skillful Peruvian silversmiths who had a personal knowledge of
pottery head jars created this series of silver vessels, which unfortunately
were then absorbed by different prominent museums at about the same
time in this century.

Ceramic vessels of a jaguar head and stirrup spout, such as the Mochica
vessel from Lambayeque in Gothenburg (Fig. 9), seem repeatedly to have
served as models for simple fakes which appeared in several museums in

75

S. Henry Wassén

the 1950s. I myself warned many colleagues, and the fakes were taken off exhibit. A typical example is a silver jar in the Montreal Museum of Fine Arts (Fig. 10), which, according to the chairman of the decorative arts department, was found "in a collection of Colonial Spanish silver made many years ago by a Canadian who had been resident in Peru" (F. Cleveland Morgan, personal communication, November 14, 1957). The Montreal museum also owns a ceramic counterpart (from the Mochica culture) to its feline effigy (Cat. 49.Ad.4), but this Mochica vessel is not quite as good a counterpart as the pottery jar shown in Figure 9. Compare, for instance, the jaguar's eyes, ears, and whiskers in Figures 9 and 10.

As this essay makes clear, a number of silver head jars from Peru have been circulated as Pre-Columbian products. With the assistance of metallurgists and silver experts it has been possible to expose them as fakes. A systematic study of collections in museums around the world would certainly expose many more such forgeries.

ACKNOWLEDGMENT. Thanks are extended to the Gothenburg Ethnographic Museum for access to old files and for providing drawings and photographs for this publication.

BIBLIOGRAPHY

BENNETT, WENDELL C.
 1937 *Ancient Peruvian Art Lent by John Wise, Esq., New York: An Exhibition of the Wadsworth Atheneum, opening March 3, 1937.* Wadsworth Atheneum, Hartford.
 1954 *Ancient Arts of the Andes.* The Museum of Modern Art, New York.
EASBY, JR., DUDLEY T.
 1955 Los vasos retratos de metal del Perú: Como fueron elaborados? *Revista del Museo Nacional, Lima* 24: 137–153.
KELEMEN, PÁL
 1944 *Medieval American Art.* 2 vols. Macmillan, New York.
LOTHROP, SAMUEL K.
 1951 Gold Artifacts of Chavin Style. *American Antiquity* 16: 226–240.
UBBELOHDE-DOERING, HEINRICH
 1952 *The Art of Ancient Peru.* A. Zwemmer, Ltd., London.

Three Aztec Masks of the God Xipe

ESTHER PASZTORY

COLUMBIA UNIVERSITY

U NTIL THE END of the nineteenth century, the Pre-Columbian art of Mexico was thought to be synonymous with Aztec art. Since then, archaeological excavations have revealed the marvels and mysteries of the Olmec, Maya, and Teotihuacan cultures which flourished many centuries before the Aztecs. These earlier wonders have come to overshadow those of the Aztecs, who are now seen as barbarian and eclectic latecomers, capable of a single burst of creativity just before they were felled by the Spanish. While excavations continually bring to light art works requiring analysis and interpretation, everything seems to have been said about Aztec art by the great turn-of-the-century scholars such as Eduard Seler and Hermann Beyer.[1] Major Aztec art works in museums, acquired many years ago, have the unquestioned patina of age and familiarity. Three famous masks, two in the British Museum and one in the Musée de l'Homme, have been reproduced and exhibited so often that they have come to represent for us the very essence of Aztec craft and sensibility (Figs. 1–3). For Henry Moore, the British Museum masks were quintessentially Aztec and he reinterpreted them in his own sculpture. He saw in them "stoniness," "power without loss of sensitiveness," "full three-dimensional conception," and "truth to material" (James 1966: 159) (Fig. 4). When examined more closely, these Xipe masks raise a number of disquieting questions.

All three masks are generally believed to represent the deity Xipe Totec, in whose honor the Aztecs performed one of their most grisly sacrifices, the flaying of the skin of a human victim. The flaying ritual took place

[1] Since 1978, when this paper was originally written, Aztec studies have undergone a renaissance due in large part to the spectacular find of the Coyolxauhqui relief and the subsequent excavation of the Templo Mayor by Eduardo Matos Moctezuma.

77

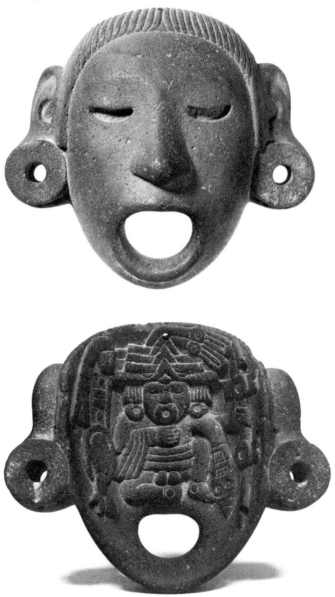

Fig. 1 Xipe mask, front and back, in the British Museum, acquired from the Henry Christy Collection. Height 23 cm., width 26 cm. Photograph courtesy of the Museum of Mankind of the British Museum.

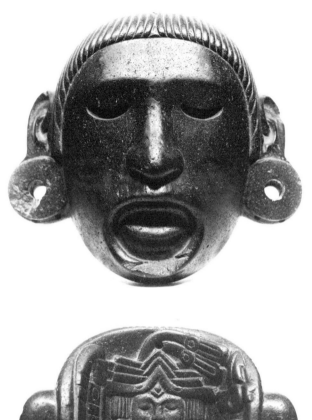

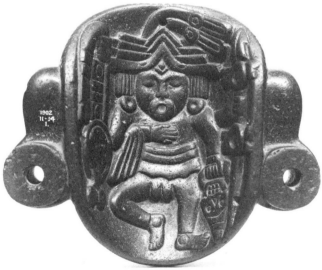

Fig. 2 Xipe mask, front and back, in the British Museum, purchased from A. P. Maudslay. Height 21 cm., width 24.5 cm. Photograph courtesy of the Museum of Mankind of the British Museum.

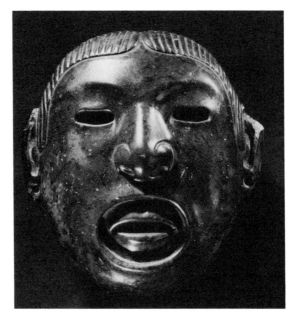

Fig. 3 Xipe mask in the Musée de l'Homme, from Teotitlan del Camino, Oaxaca. Height 10.9 cm. Photograph courtesy of the Musée de l'Homme.

Fig. 4 *Mask* by Henry Moore, 1929. Sir Philip Hendy Collection (after James 1966: 158, Fig. 51).

during the month Tlacaxipehualiztli, which was either the first or second month of the year. The ritual had both fertility and military aspects (Broda de Casas 1970). Those warriors who had captured victims for the festival were honored by gifts and watched a gladiatorial sacrifice in which a victim armed with a club and feathers fought Eagle and Jaguar knights holding obsidian-bladed weapons. The sacrifice was attended by the ruler and by guests invited from neighboring cities. Afterwards, poor men dressed in the skins and went begging from house to house for twenty days bringing fertility and good luck to those who gave them special food stuffs. Finally the skins were buried in the temple with first fruit offerings. Though many scholars have tried to interpret the meaning of the flaying sacrifice, its precise symbolism is not recorded in any source.

A number of Aztec sculptures represent Xipe Totec as a human wearing a flayed skin (Fig. 5). The powerful effect of these sculptures lies in the contrast between the sense of the living, breathing body pulsating under the dead and flaccid skin. This is epitomized in the dark cavity of the eyeholes, stretched to a mongoloid slant, that suggest living eyes within; in the open mouth, visible through the circle of the dead lips; and in the dead hands, hanging limp next to the living hands, curled to grasp a now missing object.

The British Museum masks represent the head of Xipe in the front and a relief of the full figure in the back (Figs. 1–2).[2] They are very close in size and design, but one is pierced through the mouth, while the other is not. Both masks are effigies and probably not meant to have been worn. A number of perforations on both masks indicate that they might have been attached to something. The mask without the opening through the lips is 8 3/8 inches tall, of dark acid lava stone (Fig. 2). The smooth planes of the face are beautifully modelled to reveal a sense of flesh under a taut layer of skin. The face is framed by realistically detailed ears, distended to hold large cylindrical earplugs, and by hair, carefully ordered into striations and subtly parted in the middle. The crescent eye cavities appear to look down and to focus inward. The figure on the back is shown frontally, in low relief, with one leg raised in a dancing position; the arms hold a rattle staff, a shield and spear, and a trophy head or incense bag. He wears a folded triangular hat with two plumes.

[2] I would like to thank Emily Umberger for examining the masks for me in the British Museum and the Musée de l'Homme.

Esther Pasztory

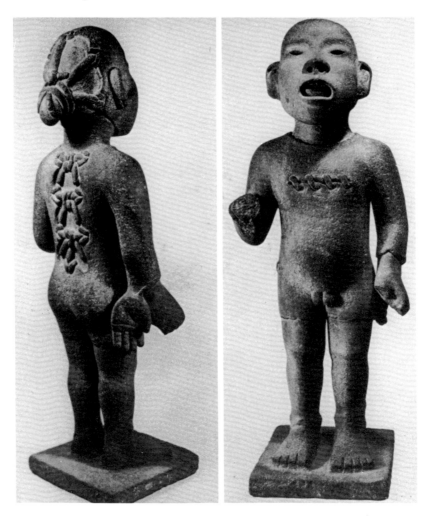

Fig. 5 Xipe Totec sculpture, front and back. Private collection, Mexico (after Westheim et al. 1972: Figs. 181, 182).

The mask with the open mouth is nearly identical in size, 9 inches, but carved from a coarser, reddish stone (Fig. 1). The figure in relief is exactly the same as the other, except that the legs are raised asymmetrically so as to leave room for the mouth opening. Because of the massive quality of the stone, the contrast of the perforation of the open mouth adds a sense of life to this mask that is missing in the other.

The mask in the Musée de l'Homme is carved out of green rhyolite and is only 4 1/4 inches high (Fig. 3). This highly polished greenstone mask is not carved on the back, but is related to the British Museum masks especially in the design of the mouth framed by the skin, and the parted and striated hair.

Because of the complexity of design, craftsmanship, and high polish, these sculptures relate to the fine sculptures made for the major temples of the Aztecs, rather than to the more crudely finished sculptures which were made in large quantities. One of the features that distinguish the works of the elite from the rest of Aztec art is the unique conception of each figure in which iconography is reinterpreted in dramatic new ways (Pasztory 1980). The anomalies to be observed in these masks may indicate that they belong to that group of ideosyncratic sculptures.

The curious detail that first drew my attention to these works is the presence of four arms on the relief figures carved on the back of the British Museum masks. Three of the arms hold objects, while the fourth is placed across the chest with what looks like drapery hanging over it. This appears to be a misunderstanding of the four hands of Xipe sculptures, of which two are alive and two are dead. There is no tradition of multiple-limbed figures in Pre-Columbian art and religion. So far I know of only one example, and that is on an Aztec skeletal figure carved on the side of a death deity. The figure was found in 1901 in the Escallerillas Street excavations in Mexico (Fig. 6). This is a frontally seated figure with a profile head (Seler 1960–61, 2: Fig. 34). An explanation of the four arms may lie in the three dimensional figure which may be based on a Janus image of two figures, including two sets of arms, placed back to back. An attempt may have been made to show in relief such a Janus figure, thus accounting for the four arms (Umberger n.d.). Whatever this four-armed skeleton may signify, it does not explain the Xipe figure in which the contrast should be based on alive and active, versus dead and passive hands; in no circumstances should the dead hands be active. The contrast is illustrated by the painting of Xipe in the Codex Borbonicus, where the living hands,

Fig. 6 Four-armed skeleton, detail of a death deity carved in greenstone. Museo Nacional de Antropología, Mexico. Height, 76 cm. Photograph by Emily Umberger.

painted red, hold a staff and shield, while the yellow dead hands merely hang down.

Four-armed deities are unlikely to be found in Aztec art because of the prevailing concepts of the human body and of divine energy. In the Aztec view, the concept of bodily perfection did not allow for multiple limbs which would have been seen as monstrous. Sahagún's description of the youth who was selected to represent Tezcatlipoca for a year and who was sacrificed at the end of that time, indicates the Aztec idea of human beauty. The chosen man had to be without blemishes, because the outer body was believed to reflect the inner state of the soul:

> For he who was chosen was of fair countenance, of good understanding and quick, of clean body—slender like a reed; long and thin like a stout cane; well-built; not of overfed body, nor corpulent, and neither very small nor exceedingly tall.
>
> For anyone who was formed [thus] defective, who was too tall,

to him the women said: "Tall one; headnodder; handful of stars!" He who was chosen impersonator was without defects.

[He was] like something smoothed, like a tomato, or like a pebble, as if hewn of wood. [He did] not [have] curly hair, [but] straight, long hair; [he had] no scabs, pustules, or boils on the forehead, nor skin growths on the forehead, nor [was he] large-headed, nor with the back of the head prominent; nor of a head shaped like a carrying-net, nor with the sutures of the crow yet soft; not broad-headed, nor with a square head. . . . Not with protruding or long ears, nor with torpid neck, nor hunch-backed, nor stiff-necked, nor with neck elongated, much elongated, nor twisted, nor kinked; neither with unduly long hands, nor lacking one hand, nor wanting both hands, nor fat-fingered . . . (Sahagún 1950–71, Bk. 2: 64–65).

There are some figures in Aztec mythology who are deformed, such as Xolotl and Nanahuatzin, but they, too, are represented with the usual number of limbs. Xipe Totec was both an agricultural and military deity, venerated especially by warriors and even by the Aztec ruler. There is no reason why he should have been given what the Aztecs would have considered a monstrous form.

Even more compelling than their view of physical perfection was the Aztec idea of divine power. Unlike the Hindu gods, who were conceived as physically powerful and whose dynamism was represented visually by the tension of dancing bodies and multiple heads or arms, according to the Aztecs divinity resided not in the body, but in costume and insignia. The body was merely the support for those objects in which the power was actually thought to reside. If the body had any special power in the Aztec view, that resided in the blood offered in sacrifice and self-mortification. Thus in the codex illustrations of the gods, the bodies are virtually identical and personality is distinguished through dress. There was therefore no ideology that a four-armed figure could represent visually in Aztec religion.

Once the problem presented by the four arms is raised, other features of the relief figure can also be seen as problematic. Frontal figures in relief are, with the exception of earth monsters and a few other reliefs, rare in Aztec sculpture (Klein 1976). The dancing pose, with one leg raised to the knee is also highly unusual. The triangular headdress is unique, and what looks like folded drapery over the arm is meaningless. And finally, while relief carvings on the backs and bottoms of Aztec sculptures are frequent, these rarely represent the

Fig. 7 Mask, front and back, in the Museum für Völkerkunde, Berlin. Height 12 cm., width 11 cm. Photograph courtesy of the Museum für Völkerkunde.

same personage who is shown on the front or top. (The Museum of the American Indian Xipe has the date 2 Reed carved on the back, and the Hamburg Museum Xipe head has a Smoking Mirror emblem.)

The closest parallel to the British Museum masks is a mask in the Museum für Völkerkunde in Berlin (Seler 1960–61, 2: 953–958) (Fig. 7). The front of the mask represents an unidentified male, while the back shows Ehecatl, the wind god, seated cross-legged, but with the head in profile, as is traditional. The front of the Berlin mask is also significant in this comparison. The face is well modelled and characteristically Aztec, as its similarity to many masks and faces of figures indicates. It is close in outline and features to a mask in the American Museum of Natural History (Ekholm 1970: 61), and to a mask in Dumbarton Oaks (Dumbarton Oaks 1963: Pl. 108). None of these masks have built-in earplugs, though most have holes for the insertion of ornaments. With the exception of the Berlin mask, none have striated hair. The striated hair of the Berlin mask consists of parallel lines without a parting suggested in the center. This is in keeping with the simple and straightforward representation of ornamental details in Aztec sculpture.

If we disregard for a moment the three masks under discussion and the Berlin mask, striated hair that is unadorned by a headdress is quite rare in Aztec sculpture. To my knowledge, only the greenstone birth-giving goddess at Dumbarton Oaks (Fig. 8) and the wood figure of a male in the Leff Collection (Easby 1966: 40–41; Nicholson and Berger 1968: Fig. 13) have striated hair without a headdress, and it is possible—although not certain—that both figures were once adorned with removable headdresses (see Nicholson 1971: 127).

The hair of the London and Paris masks is also unusual because of the part in the center, a detail of refinement that adds much subtlety to the carvings. There is no parallel to this detail on any other Aztec sculpture known to me so far, and in the whole of Aztec art only the Tlazolteotl pictured in the Codex Borbonicus (trecena 13) has hair parted in the center. Instead, the part in the hair on the three masks under discussion is reminiscent of the elegant hairline of figures in Indian and Oriental art rather than than of Aztec sculpture.

In order to understand the three Xipe masks, one must try to reconstruct the time of their appearance in the nineteenth century. It is surprising to discover how few art works were available until the middle of the century and how little was known about them. At the time of the con-

Fig. 8 Birth-giving goddess. Dum-
barton Oaks. Height 20.2 cm.,
width 12 cm. Photograph courtesy
of Dumbarton Oaks, Washington.

quest, Aztec artistic remains were considered heathen idols, to be broken
up and buried. Since they appeared primitive by classical standards, they
were not saved on aesthetic grounds. Durán wrote in his *Historia* that a
monument, which he believed was commissioned by Motecuhzoma I,
came to light during the building of the Cathedral. However significant he
might have thought that monument as an historical document, the idea of
conserving or studying it seems not to have occurred to him. He actually
thought that it should have been converted into a baptismal font: "It [is]
good that this stone be used in the service of our God, so that that which
was a container for human blood, sacrificed to the devil, may now be the
container of the Holy Spirit" (Durán 1964: 119).

In the eighteenth century educated opinion held that the Pre-Columbian
cultures were inferior. So few ancient monuments were visible, that
writers could claim that the ancient Mexican civilization was backward
because of the lack of ruins (Keen 1971: 261–309). The discovery of Pal-
enque (around 1750), Xochicalco (1784), and the Calendar Stone, Coatli-
cue, and Stone of Tizoc (1790) changed that situation, although the Stone
of Tizoc was almost cut up for paving stones and the Coatlicue was
reburied for fear of stimulating a nativistic revival.

During the first half of the nineteenth century, there was a new interest in the Aztec past. In Mexico the revival of interest in the indigenous past was associated with the War of Independence from Spain, which began in 1810 (Keen 1971). The Mexican leaders saw themselves as restorers of the Aztec empire which had been interrupted by the Spanish conquest. The Museum of Antiquities was founded in 1822 and the first nationalistic law to prohibit the removal of antiquities was adopted in 1829. European interest in Pre-Hispanic antiquities was a result of recent archaeological discoveries in Europe, such as Pompeii in 1748. Charles III, who founded the Museum for Antiquities in Naples, also ordered the exploration of Palenque. Charles IV sent Dupaix on three trips to Mexico between 1805–1808, but the War of Independence interrupted the publication of his book.

The publication of several important works on Mexican antiquities spurred great interest in America and Europe, and acquainted a wider public with new exotica. Humboldt published his *Vues des cordillères et monuments* in 1810. The Mexican museum's first publication was a set of lithographs by Waldeck in 1827 (Mexico 1827). Dupaix's volume with Castañeda's illustrations, and Nebel's book on travel and archaeology were finally published in 1834 and 1836 in Paris. Kingsborough's nine volume encyclopaedia came out between 1831 and 1848, and Prescott's influential *Conquest of Mexico* in 1844. Stephens's and Catherwood's *Incidents of Travel in Yucatan* appeared in 1843. In 1823 William Bullock traveled in Mexico and took plaster casts of famous monuments, such as the Calendar Stone and Coatlicue (dug up for the occasion but reburied), to his Piccadilly exhibition in 1824.

The dissemination of information about Mexican antiquities spurred the collection of artifacts. Bullock and Dupaix had collected numerous objects, as did a steady stream of travelers. The Englishman Henry Christy, traveling in Mexico in 1856–1857 had perhaps one of the finest collections. In the 1860s Napoleon III had sent a scientific commission, led by Eugène Boban, to collect works of art which were exhibited in 1867 at the Trocadero museum (Eudel 1909: 31). Napoleon III's interest in Mexico may have been an attempt to emulate Napoleon I's explorations in Egypt. The ill-fated Maximilian was also interested in the past and had the Mexican museum moved to a new location (Sánchez 1877: 2), which it occupied until 1964. Although most westerners still considered Aztec art to be ugly, as curiosities the objects were sought after by rulers as well as by a few private collectors.

During the first half of the nineteenth century interest in the Aztecs was romantic and sentimental. While the Aztecs were described as gruesome and bloodthirsty, they were often preferred to the Spanish, and their very barbarism was a source of exotic fascination. Many poems, novels, plays, and operas evoked the refinements of the noble savages (Keen 1971). In the absence of enough genuine available sources, fabrication flourished. Pseudo-Aztec poems were written by Pesado and Villalon in the 1850s, some attributed to Nezahualcoyotl, but bearing little resemblance to Nahuatl poetry (Martínez 1972: 145–150). (This faking actually began with Ixtlilxochitl at the end of the sixteenth and beginning of the seventeenth centuries, but he at least imitated Nahuatl conventions.)

The growing interest in Mexican antiquities could not be satisfied by accidental finds, but since the customers were not very discriminating, fakes were easily accepted. It is generally assumed at present that faking in Pre-Columbian art is a recent phenomenon and that objects that have been in collections for fifty years or more are genuine. Ekholm (1964) suggests that this is incorrect and that many old "masterpieces" may have to be reevaluated. According to Batres (1909), the manufacture of fakes goes back to the sixteenth century, when a Tlatelolco barrio was famous for souvenirs made for the conquerors. Throughout the nineteenth century, Tlatelolco and San Juan Teotihuacan were manufacturing antiquities, especially in clay. Tylor (1861: 101, 229) described that obsidian knives and clay vessels were made in great quantities in the 1850s. The Mexican museum actually had an entire room full of ceramic fakes. Tylor assumed that most fakes were ceramics because jade and obsidian objects were "cheaper to find than to make" (1861: 229). This assertion seems hard to believe considering that in the absence of archaeological information the natives could hardly be assured of finding first quality artifacts on demand.

The falsifications that were eventually recognized as such in the nineteenth century, were mainly ceramics. Clay figurines made from Pre-Conquest molds were added to newly made pottery vessels with feet and lids, resulting in compositions of baroque complexity (Figs. 9, 10). Except for the figurines, which were from genuine molds, the constructions as a whole had no precedent in Pre-Columbian art. Like the Aztec poems, they were invented out of thin air. Most remarkable is the figure of the "Dying Aztec" (Fig. 11). A famous vessel representing the entire Mexican pantheon, supposedly found in Texcoco, fell apart while it was exhibited at the Trocadero museum. It had been collected by Napoleon III's commis-

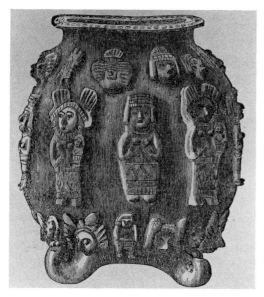

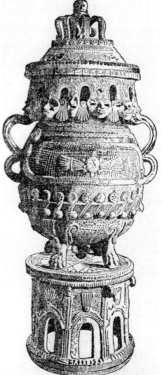

Fig. 9 *above* Drawing of a fake vessel (after Holmes 1889: 331, Fig. 16).

Fig. 10 *right* Drawing of a fake vessel (after Holmes 1889: 327, Fig. 8).

Fig. 11 Drawing of a fake clay figure (after Holmes 1889: 329, Fig. 13).

sion (Eudel 1909: 31–32). On his first trip to Mexico in 1878, Desiré Charnay had copies made of many vessels in the Mexican museum before he realized that all the ones he had copied were fakes (1885: 37–38). By 1889, the corpus of Tlatelolco fake ceramics was recognized, and Holmes dealt it the final blow in publication. He estimated that three-fourths of the objects in collections were fakes, including works in wood, gold, bronze, and quartz. In his 1909 book on fakes, Batres included works in clay, gold, silver, obsidian, and marble. Between 1830 and 1866 alabaster vases were imported from Italy and carved with pseudo-Mexican scenes and glyphs. Batres said that artisans specialized in different media, and he published the photographs of several artists in their workshops, adding the intriguing information that most forgers were alcoholics.

In reconstructing the artistic climate of the nineteenth century, it is important to recognize how long the most absurd fakes could fool even the specialists. In part this was the result of not having enough authentic objects available for analysis. But this is not the entire explanation. Until the second half of the century, westerners could not *see* the stylistic quali-ties of Mexican art, as indicated by the drawings published in the books of Dupaix, Waldeck, and Gondra.[3] The dramatic conventionalization so char-acteristic of Pre-Columbian art was for them invisible. The drawings indi-cate the artists' desire to grasp an alien style through some details, but they then filled in the rest with hesitant outlines, smooth surfaces, or European conventions. On many plates it is impossible to tell the would-be cultural affiliations of the monuments (Fig. 12). Given the general inability to comprehend the Pre-Columbian style, it is not surprising that objects that did not even look Pre-Columbian could pass as genuine.

As there were two major groups of collectors—ordinary travelers look-ing for inexpensive souvenirs and well-to-do collectors willing to pay high prices for unusual antiquities—there were two kinds of falsifications. The cheap clay forgeries were eventually recognized, but some of the fine ones may still be around. That they did exist is indicated by the case of the gold statuette of Tizoc. This piece was published by Saville (1929: frontispiece) but was proven by Easby and Dockstader (1964) to be a fake on the basis of style and technique. The maker of the piece was far from naive. He was familiar with Pre-Columbian art including the day signs and the ruler's

[3]This does not mean that all illustrations were badly drawn, but that correctness was the exception rather than the rule. Catherwood's drawings for Stephens' volume are particularly remarkable for their high quality of verisimilitude at a time when that was highly unusual.

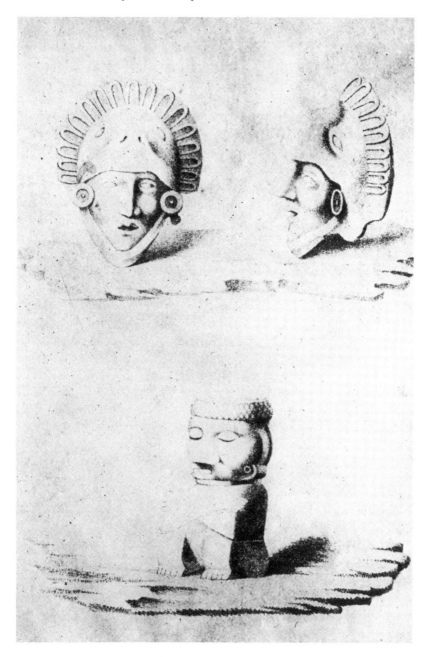

Fig. 12 Drawings of a head and a stone figure (after Mexico 1827: 13th plate).

name glyphs, since both appear on the figure. The famous rock crystal skulls in the Musée de l'Homme (acquired by Boban) and in the British Museum (purchased from Tiffany in 1898) present a similar problem of well-made objects in precious media of problematic authenticity. Ekholm (1964: 25–26) considers all large objects of obsidian, especially masks, to be of questionable authenticity. He points out that masks were, and still are, one of the most popular types of faked sculptures.

We do not have a complete history of the Xipe masks. The British Museum mask with the open mouth was in the Christy collection by 1861 and was illustrated by Tylor in his book (1861: facing p. 226) (Fig. 1). The other mask (Fig. 2) in the British Museum was bought from Alfred Maudslay in 1902. According to the catalogue notes of the British Museum, it came from Texcoco. This may not be significant. In the nineteenth century Texcoco was believed to have been the artistic capital of the Aztec empire, and many objects were attributed to that city. The mask in the Musée de l'Homme was said to have come from Teotitlan del Camino in Oaxaca (Musée de l'Homme catalogue notes). It was collected by Boban for Napoleon III in the 1860s, as was the famous Quetzalcoatl and the infamous Texcoco vase. A fourth Xipe mask of greenstone, without hair designs, was in the estate of the emperor Maximilian in 1868 and was acquired by the Vienna Museum für Völkerkunde in 1881 (Museum für Völkerkunde catalogue notes) (Fig. 13). The Berlin mask was given to the Museum by Seler in 1905, but he said that it had been in a Mexican collection for at least fifty years (1960–61, 2: 953). Except for the Maudslay mask—which must have been made by the same artist who carved the Christy mask—all these Xipe masks and the Berlin mask came to light between 1850 and 1870, the time when Aztec scholarship was still very limited and fakes were not easily recognized.

It is significant to note that these masks were not identified as the god Xipe at the time they were found, because Xipe, as a type of sculpture, does not appear to have been defined prior to 1901 (Seler 1960–61, 2: 910–912). The catalogue of the Christy collection published in 1862 did not identify the deity represented by the mask (British Museum 1862: 32).[4] The relief was described as the figure of a god or priest. The large earplugs were compared to Malay and Brazilian Indian earplugs. As far as the

[4] I would like to thank Elizabeth Carmichael, the curator of the British Museum, for sending me a copy of the Christy collection catalogues.

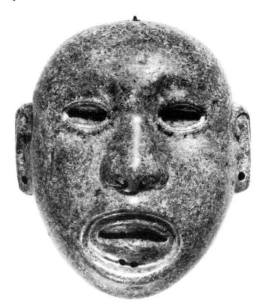

Fig. 13 Xipe mask. Museum für Völkerkunde, Vienna. Height 21.5 cm., width 19.5 cm. Photograph courtesy of the Museum für Völkerkunde.

mask's function was concerned, the explanation given was that "old manuscripts tell us that it was customary to mask the idols when the king fell sick, or in the case of other public calamities." In 1897 Hamy (p. 22) accepted Rosny's (1875) identification of the Paris greenstone mask as the Mexica priest wearing the skin of the Culhuacan princess who was flayed in an episode of the early Aztec migration history. Moreover, the large diorite head we are accustomed to call Coyolxauhqui (Fig. 16) was identified as Xipe by Chavero in 1887 (p. 317).

Xipe sculptures were very rarely represented among the nineteenth century illustrations of Aztec art, and were not called Xipe. Nebel (1836) illustrated a seated Xipe figure (Fig. 14) but did not identify it as such. Chavero (1887: 317) illustrated a large (over a meter high) ceramic Xipe figure, but identified it on the basis of a pectoral as a "Xiuhtletl," or fire god (Fig. 15). He interpreted the extra hands as living and said that the multiplicity of arms signifies expressively that this is a creator god.[5]

Several visual sources are behind the British Museum Xipe masks. The front of the face appears to be based on Xipe faces, as illustrated by Nebel

[5]In 1897 Saville identified a terracotta Xipe figure as a warrior wearing a quilted armor (Beyer 1965: 343).

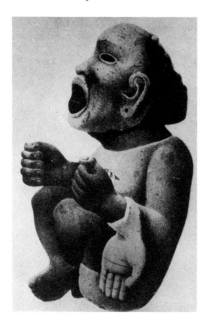

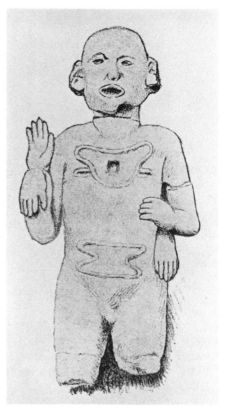

Fig. 14 *above* Drawing of a Xipe figure (after Nebel 1836: Pl. 46).

Fig. 15 *right* Drawing of a Xipe sculpture (after Chavero 1887: 317).

and Chavero, but with a number of aspects derived from the head of Coyolxauhqui (Fig. 16). That head was found in 1829 and was one of the major monuments of the Mexican National Museum. There is a general similarity in the striated hair, the heavy earplugs in the ears, and especially the shape of the eyebrows and eyelids. However, while the earplugs make sense on Coyolxauhqui, because it represents a decapitated head, they are questionable on a mask. Another possible prototype for the front of the British Museum masks is a clay panel of a mask with dead eyes, open mouth, and large earplugs in the Mexican National Museum. This plaque was published by Gondra in 1844–1846 in a monograph on the holdings of the museum. The book was the third volume appendix to Prescott's *Conquest of Mexico*. Gondra described the figure as Quetzalcoatl (Fig. 17).

The concept of a relief on the back of the masks probably also originated

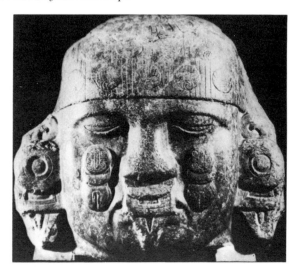

Fig. 16 Coyolxauhqui head. Museo Nacional de Antropología, Mexico. Height 36 in., width 42 in., diameter 30 in. Photograph courtesy of the Museo Nacional de Antropología.

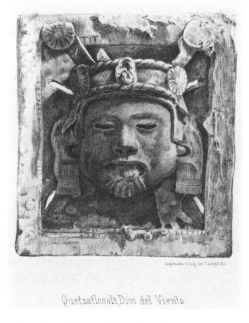

Fig. 17 Drawing of a clay plaque (after Gondra 1844–46: no figure or page numbers). Photograph courtesy of The New York Public Library.

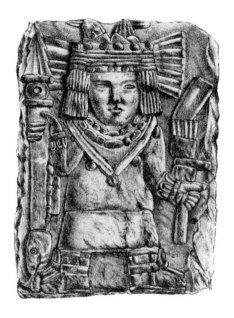

Huitzilopuxtli, Dios de la guerra.

Fig. 18 Drawing of a relief of a maize goddess (after Gondra 1844–46: no figure or page numbers). Photograph courtesy of The New York Public Library.

from reliefs seen on the backs and undersides of sculpture such as the Coyolxauhqui or the Berlin mask. The four-armed dancing figure carved in relief appears to combine the four "arms" of the freestanding sculptures of Xipe with specific details taken from relief panels of frontal figures holding insignia (Fig. 18). Following the clay plaque in his book, Gondra (1844–46) illustrated this relief of a maize goddess holding a maize plant and a rattle staff. He identified the figure as Huitzilopochtli, the Aztec war and patron deity. This relief was one of the most frequently illustrated Aztec sculptures in the nineteenth century (Siegel 1953).[6] The headdress of the British Museum figure appears to be a free adaptation of the maize goddess, with the two corncobs transformed into plumes, and a spear and shield added to the rattle staff. In his text, Gondra associated sacrifice by flaying with the cult of Huitzilopochtli.

There are two possible conclusions. The Xipe masks may be genuine,

[6]The relief was acquired by the Brooklyn Museum in 1951.

idiosyncratic works. Such sculptures did exist, as the dancing monkey figure, excavated during the construction of the Metro, demonstrates (Gussinyer 1970). The fluid moving pose of that sculpture is quite different from the rigid and static canons we accept as characteristically Aztec. If that piece had not been excavated but found in a collection, it might have been difficult to accept as genuine.

The second possibility is that the masks were made in the middle of the nineteenth century by a carver who was familiar with Aztec art in the Mexican museum, but who did not fully understand Aztec iconography, which is not surprising, because at that time few people did. It is unlikely that the carver of the masks intended to represent the god Xipe, as we know it today. That identification was not conclusively related to these figures until 1901 by Seler.

Although the carver must have been familiar with a number of Aztec art works, his major source appears to have been Gondra's book, in which he used two adjacent pictures for inspiration for the front and back of his mask. If he read the text at all, he would have found ample justification for Indian details. Gondra interpreted Aztec art by references to all other ancient cultures known to him—Egyptian, Hebrew, Indian, and Greek. He called Tezcatlipoca the "Brahma" of the Aztecs. The commentary, for the relief he calls Huitzilopochtli, consists of an essay on the similarities between Aztec, Egyptian, and Indian religions. He derives the Nahuatl word for temple, *teocalli,* from Kali—the terrible Indian goddess who wears a skull necklace—and from *theos,* the Greek work for god (Gondra 1844–46: 68, 70–71, 77). Considering the skill devoted to the making of the masks and prototypes used as models, nothing less than the most important Aztec god must have been intended—Huitzilopochtli, god of the sun, of war, and patron of the Aztec ruling class: a Pre-Columbian equivalent of Siva, the destroyer. The interpretations of Gondra's book soon became outdated, but the masks have not been questioned until now. The combination of a gruesome subject, such as sacrifice by flaying, treated with exquisite refinement and elegance, added to the exoticism of a four-armed dancing figure, is the prefect embodiment of what the mid-nineteenth century thought of as the savage yet noble art of the Aztecs.

POSTSCRIPT. These Xipe masks have come to exemplify Aztec art to such an extent that they have been the inspiration for several obvious later forgeries. In his book on fakes, Batres (1909) published a crude marble

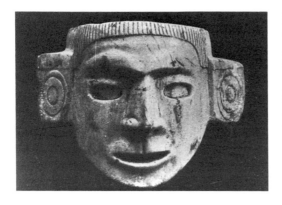

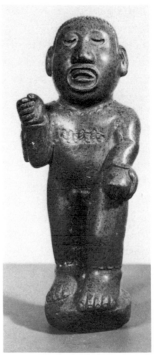

Fig. 19 *above* Mask in marble (after Batres 1909: Pl. 62).

Fig. 20 *right* Xipe statuette. Dumbarton Oaks. Height 23.5 cm. Photograph courtesy of Dumbarton Oaks, Washington.

mask of a face with striated hair and earplugs that was clearly modelled on the British Museum Xipe masks (Fig. 19). In the Dumbarton Oaks collection, a small, greenstone Xipe statuette (the authenticity of which has been questioned) has parted striated hair, and facial features that are possibly in imitation of the mask in the Musée de l'Homme (Fig. 20). If it is false, it may have been carved during the first half of the twentieth century when these masks were already identified as Xipe figures.

In addition, H.B. Nicholson has kindly brought to my attention photographs of a relief in the Echániz collection that show a monument similar to the relief on the back of the British Museum masks (Fig. 21). The Echániz sculpture is a rectangular block with relief on all sides. The correspondence of details is striking: the face and headdress are nearly identical, one arm is across the chest, and the other arms hold rattle staffs carved on the back. In fact, there are no elements in the relief that do not have a parallel in the British Museum masks.

There are several elements in the Echániz relief that do not fit within

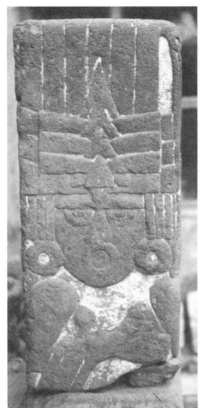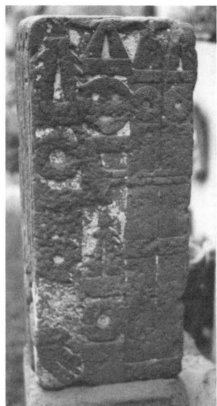

Fig. 21 Stone relief, front and back. Private collection, Mexico. Photograph by H. B. Nicholson.

Aztec conventions: arms are wrapped around the front, side, and back in a diagonal; the arm across the chest is oddly misshapen; and the rattle staffs on the back, especially the two placed one on top of the other, do not make any iconographic sense. It is my opinion that the relief was carved after an illustration of the British Museum mask, which was published as early as 1861.

BIBLIOGRAPHY

BATRES, LEOPOLDO
 1909 *Antigüedades mejicanas falsificadas.* Soria, Mexico.

BEYER, HERMANN
 1965 ¿Guerrero o dios? *El Mexico Antiguo* 10: 343–352.

BRITISH MUSEUM
 1862 *Catalogue of a Collection of Ancient and Modern Stone Implements, and of Other Weapons, Tools, and Utensils of the Aborigines of Various Countries, in the Possession of Henry Christy, F. G. S., F. L. S., &c.* Catalogued by M. Steinhauer. Printed privately, London.

BRODA DE CASAS, JOHANNA
 1970 Tlacaxipeualiztli: A Reconstruction of an Aztec Calendar Festival from 16th Century Sources. *Revista Española de Antropología Americana* 5: 197–224.

BULLOCK, WILLIAM
 1824a *Six Months Residence and Travels in Mexico.* John Murray, London.
 1824b *A Description of the Unique Exhibition called Ancient Mexico.* J. Bullock, London.

BURLAND, C. A.
 1973 *Montezuma Lord of the Aztecs.* G. P. Putnam's Sons, New York.

CHARNAY, DÉSIRÉ
 1885 *Les anciennes villes du Nouveau Monde.* Hachette et Cie., Paris.

CHAVERO, ALFREDO
 1887 Historia antigua y de la conquista. In *Mexico a través de los siglos* (Vicente Riva Palacio, ed.) 1. Espasa, Barcelona.

DUMBARTON OAKS
 1963 *Handbook of the Robert Woods Bliss Collection of Pre-Columbian Art.* Dumbarton Oaks, Washington, D.C.

DUPAIX, GUILLERMO
 1834 *Antiquités mexicaines.* 2 vols. Bureau des antiquités mexicaines, Paris.

DURÁN, DIEGO
 1964 *The Aztecs, The History of the Indies of New Spain* (D. Heyden and F. Horcasitas, trans.). Orion Press, New York.

EASBY, JR., DUDLEY T., and FREDERICK J. DOCKSTADER
 1964 Requiem for Tizoc. *Archaeology* 17: 85–90.

EASBY, ELIZABETH K.
 1966 *Ancient Art of Latin America from the Collection of Jay C. Leff.* The Brooklyn Museum, New York.

Three Aztec Masks of the God Xipe

EKHOLM, GORDON F.
 1964 The Problem of Fakes in Pre-Columbian Art. *Curator* 7: 19–32.
 1970 *Ancient Mexico and Central America.* The American Museum of Natural History, New York.

EUDEL, PAUL
 1909 *Falscher Künste.* Grunow, Leipzig.

GONDRA, ISIDRO
 1844–46 Explicacion de las láminas pertenecientes a la historia antigua de México y a la de su conquista. In William Hickling Prescott, *Historia de la conquista de Mexico* 3. Ignacio Cumplido, Mexico.

GUSSINYER, JORDI
 1970 Deidad descubierta en el Metro. *Boletín del Instituto Nacional de Antropología e Historia* 40: 41–42. Mexico.

HAMY, JULES THÉODORE ERNEST
 1897 *Galerie americaine du Musée d'ethnographie du Trocadero.* E. Leroux, Paris.

HOLMES, WILLIAM HENRY
 1889 On Some Spurious Mexican Antiquities and Their Relation to Ancient Art. *Smithsonian Institution Annual Report, 1886:* 319–334. Washington, D.C.

HUMBOLDT, ALEXANDER VON
 1810 *Vue des cordillères et monuments des peuples indigènes de l'Amèrique.* F. Schoell, Paris.

JAMES, PHILLIP BRUTTON
 1966 *Henry Moore on Sculpture.* Macdonald, London.

KEEN, BENJAMIN
 1971 *The Aztec Image in Western Thought.* Rutgers University Press, New Brunswick, New Jersey.

KINGSBOROUGH, VISCOUNT (EDWARD KING)
 1831–48 *Antiquities of Mexico, Comprising Facsimiles of Ancient Mexican Paintings and Hieroglyphics.* 9 vols. A. Aglio, London.

KLEIN, CECELIA
 1976 *The Face of the Earth.* Garland Publishing, New York.

MARTÍNEZ, JOSÉ LUÍS
 1972 *Nezahualcoyotl, vida y obra.* Fondo de Cultura Económica, Mexico.

MEXICO, MUSEO NACIONAL
 1827 *Colección de las antigüedades mexicanas que existian en el Museo Nacional* (Engravings by Federico Waldeck). Mexico. (Reprint: 1927).

NEBEL, CARL
 1836 *Voyage pittoresque et archaeologique dans la partie la plus interessante du Mexique.* M. Moench, Paris.

NICHOLSON, H. B.
 1971 Major Sculpture in Pre-Hispanic Central Mexico. In *Handbook of Middle American Indians* (Robert Wauchope, Gordon F. Ekholm, and Ignacio Bernal, eds.) 10: 92–134. University of Texas Press, Austin.

NICHOLSON, H. B., and RAINER BERGER
 1968 Two Aztec Wood Idols: Iconographic and Chronologic Analysis. *Studies in Pre-Columbian Art and Archaeology* 5. Dumbarton Oaks, Washington.

PASZTORY, ESTHER
 1980 Masterpieces in Aztec Art. *XLII International Congress of Americanists, 1976* 12: 377–390. Paris.

PRESCOTT, WILLIAM HICKLING
 1844 *History of the Conquest of Mexico.* 3 Vols. R. Bentley, London.

ROSNY, LUCIEN DE
 1875 Recherches sur les masques, le jade et l'industrie lapidaire chez les indigènes de l'Amerique antique. *Archives de la Société Américanistes de France* (n.s.) 1: 308. Paris.

SAHAGÚN, BERNARDINO DE
 1950–71 *The Florentine Codex* (Arthur J. O. Anderson and Charles E. Dibble, trans.). School of American Research, Santa Fe.

SÁNCHEZ, JESÚS
 1877 Reseña histórica del Museo Nacional de Mexico. *Anales del Museo Nacional* 1: 1–2. Mexico.

SAVILLE, MARSHALL H.
 1929 Tizoc; Great Lord of the Aztecs. *Contributions from the Museum of the American Indian, Heye Foundation* 7 (4). New York.

SELER, EDUARD
 1960–61 *Gesammelte Abhandlungen zur Amerikanischen Sprach- und Alterthumskunde* 5 vols. Akademische Druck- und Verlagsanstalt, Graz.

SIEGEL, FLORA
 1953 An Aztec Relief in the Brooklyn Museum. *The Brooklyn Museum Bulletin* 4 (4): 8–14.

STEPHENS, JOHN LLOYD
 1843 *Incidents of Travel in Yucatan.* Harper and Brothers, New York.

TYLOR, SIR EDWARD BURNETT
 1861 *Anahuac; or Mexico and the Mexicans.* Longman, Green, Longman and Roberts, London.

UMBERGER, EMILY
 n.d. Aztec Sculptures, Hieroglyphs and History. PhD dissertation. Columbia University, Department of Art History and Archaeology, New York, 1981.

WESTHEIM, PAUL, ALBERTO RUZ, PEDRO ARMILLAS, RICARDO DE ROBINA, and ALFONSO CASO

1972 *Prehispanic Mexican Art* (Lancelot C. Sheppard, trans.). G. P. Putnam's Sons, New York.

Problems in the Study of Narrative Scenes on Classic Maya Vases

DICEY TAYLOR

UNIVERSITY OF VIRGINIA

TOWARD THE CLOSE of the Classic Period (A.D. 670–830), Maya vase painters decorated polychrome vessels with narrative scenes. A number of these vases have been known since the turn of the century, but they have appeared on the art market in quantity only during recent years. Most were illicitly removed from tombs and caches and have thus reached collectors without archaeological provenance. The study of figural scenes on vases has, nevertheless, opened vistas into ancient Maya society. Monumental sculptures of the Classic Period usually depict rulers in elaborate regalia, and the associated inscriptions yield cryptic information on the dynastic history of royal families. These monuments were commemorative sculptures intended for the public spaces of Maya cities; they tell us little of how the Maya actually lived.

Most vase paintings show events and occasions from the daily life of the upper class, including palace audiences, court processions, warriors in combat, ball games and religious ceremonies (Adams 1971: 71; Gifford 1974: 84; Paul 1976: 118–126; Kubler 1977: 15–23). Some represent mythological episodes that may be preserved in written sections of a later manuscript called the *Popol Vuh* (Coe 1973: 11–16). Although these scenes appear to depict gods, many figures are probably deity impersonators (Quirarte 1979). Regardless of difficulties in the identification of the figures, supernatural scenes are perforce based upon real life, and the vases present similar activities (audiences, processions, rituals). Narrative scenes on vases are thought to reflect a tradition of wall painting (Kubler 1975: 175), of which there are few surviving examples.

The principal concern of studies on Maya vase painting has been icono-

graphic, although some writers have analyzed the hands of particular art-
ists and local workshops (Coe 1973, 1975; Coggins n.d.; Kerr and Kerr
n.d.). No one, however, has attempted a survey of vase painters and
regional schools. Attributions of this kind are difficult to make because the
vases are dispersed among collections around the world. Yet, under simi-
lar conditions, a Classical scholar named John D. Beazley (1956, 1968) was
able to catalogue hundreds of vase painters working in ancient Greece (*ca.*
600–400 B.C.) by assembling an extensive photographic file. Greek vases
also depict everyday scenes and mythological stories, and the techniques of
their production were not unlike those of the Classic Maya. Thus, Beaz-
ley's research stands as a model for future studies on Maya vase painters.

Unfortunately, few Maya vases have survived antiquity intact. Some
damage is caused by inherent flaws in pigments and clays, but more serious
problems stem from low firing temperatures. Most Late Classic vases were
fired between 600–700 degrees centigrade because, at higher temperatures,
the paints used by the Maya become dark and murky from excessive
vitrification.[1] Clays remain porous, however, at low temperatures and are
thus susceptible to disintegration in a humid environment. Depending upon
the conditions of their burial, Maya vases may suffer from percolation of
water, abrasion, breakage, and the action of calcium deposits and acids in
the soil. Once the surface of a Maya vase is scratched, the underlying
ground often deteriorates, and with it the painted scene. By way of con-
trast, the Greeks were able to fire vases at temperatures of 825–950 degrees
centigrade (Noble 1965: 75), which served to strengthen both the fabric and
the surface of vessels. In tombs, Greek vases may acquire salt deposits that
cause the surface to flake, but the paint itself does not disintegrate.

While attitudes towards the preservation of antiquities are subject to
change, they tend to conflict in any era with the interests of the art histo-
rian. Restoration may enhance a work of art for the general public, but it
frequently obscures and occasionally destroys historical information. A
distinction should be drawn here between trained conservators who regard
original paint as sacrosanct (Plenderleith and Werner 1971: 180) and those

[1] I am indebted to Robert Sonin, a trained conservator from New York City, for comments
on the firing temperatures and techniques of painting Late Classic vases. Mr. Sonin kindly
reviewed the final draft of this paper. For further information on the necessity of low firing
temperatures for Maya ceramics, see Anna Shepard (1956: 381) and Shepard in Eric Thomp-
son (1939: 270). Miss Shepard allows a margin of 600–800 degrees centigrade for the firing
process, but experiments undertaken by Mr. Sonin indicate that temperatures could seldom
have exceeded 700 degrees centigrade.

who attempt to rectify the vicissitudes of time. The restoration of Maya vases has largely been undertaken by art dealers in an effort to augment the market value of vessels. Their techniques include filing the edges of sherds for smooth joins, cleaning vessel surfaces with sandpaper, retracing figures and glyphs, and inpainting new motifs to cover losses. In general, these practices entail the removal or damage of original paint and other irreversible procedures.

Three vases are used here to illustrate problems in the study of restored scenes on vessels that were purchased from art dealers within the last ten years. The photographs, published in black and white, show the condition of each vase before and after restoration. While they make it difficult to examine coloristic effects, the following comments should provide a sufficient introduction to the techniques of the Maya vase painter. In attempts at restoration, few modern paints can duplicate the Maya palette, and many can permanently stain the soft ground of vessels. Those shown here were probably restored with acrylics or other paints that produce solid, flat colors. Thus, the study of repainted vases presents the student with several kinds of problems. There may be changes in the colors and techniques of the artist as well as the possibility of new motifs.

Basic to the work of the Maya vase painter was a colloidal slip made of the finest particles of clay in liquid suspension. The more common slip has an orange color, and it may have been refined from the same iron-bearing clay used in the fabric of vessels. Another slip came from a white clay. These slips were applied in different concentrations for deep tones of orange, reddish brown and opaque white, and could be diluted to pale tints of orange, yellow and translucent white. Soft hues of rose and red were obtained by mixing crushed hematite with the white slip. Iron manganese paint provided a color ranging from dark brown to black. A bluish effect was occasionally created with a gray wash.[2]

In preparing to decorate a vase, the artist primed the ground of the vessel with one or more coats of the white slip. He then drew the outlines of the scene in continuous graduated strokes with manganese paint. While it is not known what kind of brush was employed for contours (Grieder n.d.: 82; Coe 1977a: 336), the result was a modeled line similar to that found in Oriental calligraphy. Interior details of figures and the backdrop to the

[2]Although no publication is available on the techniques of Maya vase painting, general comments are to be found in Shepard (1956), Grieder (n.d.), Coe (1973, 1977a), and Coggins (n.d.).

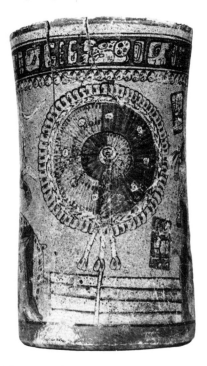 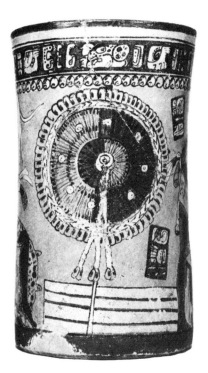

Fig. 1 Ball Court Vase, before and after reconstruction. Private collection. Photographs courtesy Foundation for Latin American Anthropological Research.

scene were filled in with clay slips. Some vase painters used a single or multiple resist technique (negative painting) whereby areas of the design were reserved with an impermeable substance such as wax that would disappear in firing. The practice of painting scenes in layers of thinly-colored slips gives Maya vases their characteristic gloss and luminosity.

BALL COURT SCENE

The first vase (Figs. 1–5) depicts a ball game between two players in front of a terraced court. The players wear a typical costume that protects the torso with a padded sash and one leg with a knee mask and heelguard; as on other ball court vases, these men represent two teams that are distinguished from one another by animal and avian headdresses (Figs. 2, 4). The scene is closed on the back of the vase by a feathered shield that

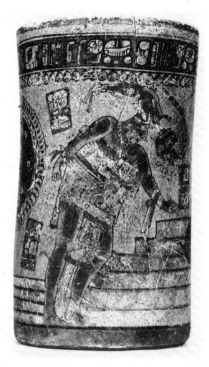
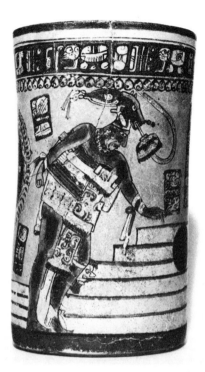

Fig. 2 Ball Court Vase, before and after reconstruction. Private collection. Photographs courtesy Foundation for Latin American Anthropological Research.

stands in front of the court behind the left player (Fig. 1). The rim text has glyphs from the Primary Standard Sequence (Coe 1973), while short columns of glyphs around the players probably contain historical names and titles (Figs. 1–5). This vase was painted in red, black, rose, and white against a pale orange background.

Because the ball court scene was well preserved, this vase needed little restoration. Several cracks in the vessel were sealed (Fig. 1), and a large fragment was mended that runs from the feathered shield through the headdress of the left player and rim text above (Figs. 1, 2). The surface of the vase was then cleaned of dirt and small deposits. At this point, a trained conservator would have considered his task to be complete. Whoever actually worked on the vase felt it necessary to add some paint. If we compare the feet of the players, the shell motifs suspended from the rim

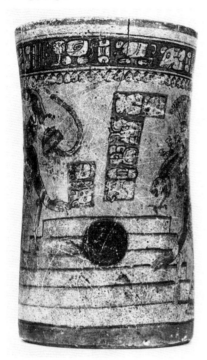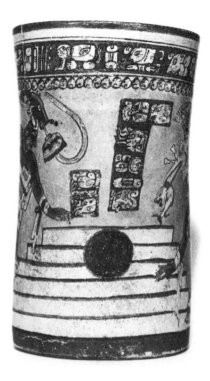

Fig. 3 Ball Court Vase, before and after reconstruction. Private collection. Photographs courtesy Foundation for Latin American Anthropological Research.

band and the hip-cloth designs of both players (Figs. 2–4), we can see that many faded outlines have been repainted.

While these additions are relatively minor, there are some disturbing changes in the glyphs. The central panel between the players (Fig. 5) begins with an illegible prefix followed by an Ahau glyph, but the restored version shows a new prefix, and the Ahau sign has been retraced along with all of the other glyphs. To the left of this panel, a short text of two compounds starts with a possible Lamat glyph that has been changed to a hand-head sign. A destroyed glyph in the rim text along a crack line has undergone a similar transformation (Fig. 3). Since the recognition of individual glyphs depends upon fine distinctions among elements, even small changes in an inscription can lead to gross errors in decipherment.

Fig. 4 Ball Court Vase, before and after reconstruction. Private collection. Photographs courtesy Foundation for Latin American Anthropological Research.

Fig. 5 Ball Court Vase, before and after reconstruction. Private collection. Photographs courtesy Foundation for Latin American Anthropological Research.

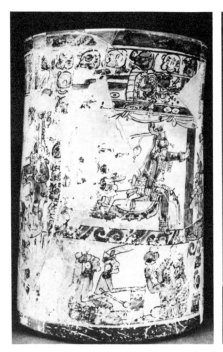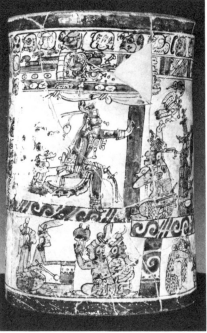

Fig. 6 Mythological Vase, before and after reconstruction. Indiana University Art Museum. Left photograph courtesy Michael Coe; right photograph by Ken Strothman, courtesy Indiana University Art Museum.

MYTHOLOGICAL SCENE

The second vase (Figs. 6–10) presents a complex but badly preserved mythological scene. Painted in red and black on white, this vase was surely discovered in fragments. There are many crack lines on the surface, and missing sections have been replaced with white patches. The scene depicts at least two events, beginning with the palace gathering on the left (Figs. 6, 7), followed by two men standing at the center of the scene (Fig. 8). Finally, to the right, trees and climbing figures seem to grow from a reptilian head (Fig. 10). Although the restoration of the vase left principal figures in the scene untouched, a number of smaller motifs have been repainted. Underneath the litter in front of the palace (Fig. 7), for example, a creature tending a brazier was almost effaced, but it now appears to be a frog or perhaps a lizard.

A possible interpretation of the mythological scene is given here to

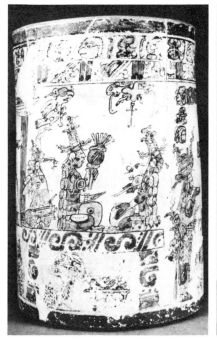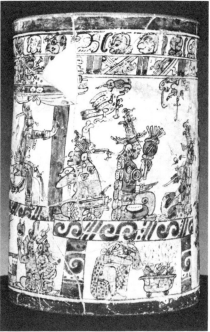

Fig. 7 Mythological Vase, before and after reconstruction. Indiana University Art Museum. Left photograph courtesy Michael Coe; right photograph by Ken Strothman, courtesy Indiana University Art Museum.

demonstrate how repainted motifs can lend support to scholarly research. The events illustrated by the vase painter may pictorialize some adventures of the Hero Twins as described in the *Popol Vuh* (Recinos, Goetz, and Morley 1950: 139–142), but comparative views of the scene indicate that such an interpretation has been facilitated by the efforts of the restorer. Key to the interpretation is the presence of two men on the litter in front of the palace (Fig. 7). They wear cloth headbands and have different facial markings; the man on the left has a black dot on his cheek and the other has three spots. The same figures stand facing one another in the center of the scene (Fig. 8). These men probably represent the Hero Twins in one of their various disguises (Coe 1978: 58–60).

The Hero Twins of the *Popol Vuh* were brothers who became deities through a series of ordeals in the Maya Underworld. After descending below the surface of the earth, the Hero Twins are asked by the gods to perform impossible tasks. Through cleverness and trickery, they invaria-

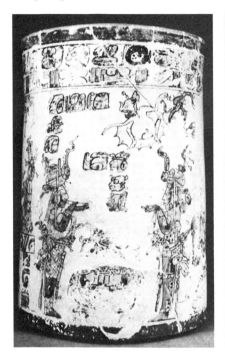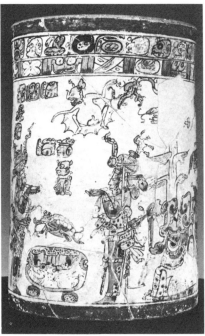

Fig. 8 Mythological Vase, before and after reconstruction. Indiana University Art Museum. Left photograph courtesy Michael Coe; right photograph by Ken Strothman, courtesy Indiana University Art Museum.

Fig. 9 Mythological Vase, before and after reconstruction. Indiana University Art Museum. Left photograph courtesy Michael Coe; right photograph courtesy Foundation for Latin American Anthropological Research.

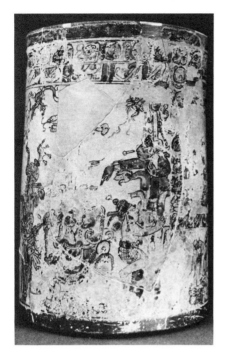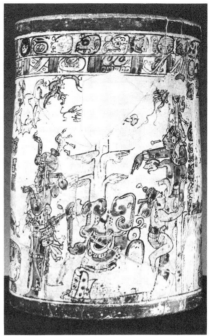

Fig. 10 Mythological Vase, before and after reconstruction. Indiana University Art Museum. Left photograph courtesy Michael Coe; right photograph by Ken Strothman, courtesy Indiana University Art Museum.

bly succeed. The adventures of the Hero Twins resemble the Labors of Herakles in Greek mythology. On the vase, the palace gathering may depict the arrival of the Hero Twins in the Underworld (Figs. 6, 7). The occasion is presided over by the god of Pax, a deity associated with sacrifices in mythological scenes; one of the musicians under the palace may be another Underworld deity known as God N, but his characteristic netted headdress and old face have been repainted (Fig. 6).

The center of the mythological scene shows the Hero Twins smoking cigars while the insect flying between them hovers over the head of a reptilian monster (Fig. 8). Michael Coe suggested, in conversation, that this event parallels the episode from the *Popol Vuh* in which the Hero Twins are asked to spend the night in a House of Gloom using pine torches and cigars to light their way (Recinos, Goetz, and Morley 1950: 142–143). The gods required, however, that the torches and cigars be returned to them unlit. The Hero Twins were able to outwit the gods by

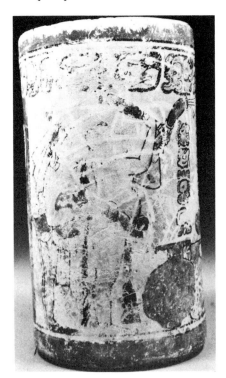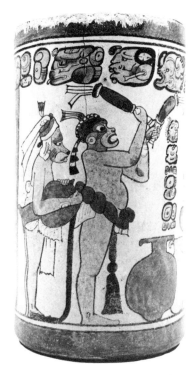

Fig. 11 Enema Vase, before and after reconstruction. Private collection. Photographs courtesy David Joralemon.

attaching red feathers to the torches and fireflies to the ends of their cigars. In order to connect this narrative to the central event on the vase, it is necessary to identify the flying insect between the Hero Twins as a firefly. The insect, in fact, has the segmented body of a firefly, but its present appearance is largely the work of the restorer (Fig. 9).

The last section of the vase showing trees and small figures growing from a reptilian head may not be an event (Fig. 10). While the significance of reptilian monsters in Maya art is not known, some probably function as glyphic signs denoting the seat of power or authority (Kubler 1977: 12–13), or in other instances, the location of action. The reptilian head with trees and figures, as well as the head between the Hero Twins (Fig. 8), belongs to the Cauac monster, a dragon that seems to be associated with places of enclosure, such as a niche or cave (Taylor 1979). There is, moreover, some evidence that the Houses of Gloom and Darkness mentioned

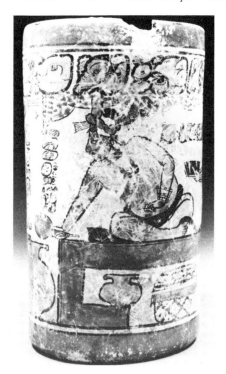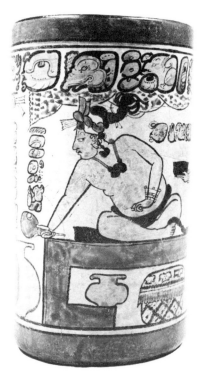

Fig. 12 Enema Vase, before and after reconstruction. Private collection. Photographs courtesy David Joralemon.

in the *Popol Vuh* refer to caves because they are described as having bats and underground rivers (MacLeod and Puleston 1979). The use of Cauac heads in the mythological scene and the bat above the Hero Twins (Figs. 8, 10) further links the central event on the vase to the House of Gloom episode from the *Popol Vuh*. This interpretation is unhappily flawed by its reliance upon motifs—the firefly and reptilian heads—that have been repainted.

PALACE SCENE

The restoration of the third vase represents a travesty of the original painting (Figs. 11–14). Half of the scene was destroyed, probably through water damage (Fig. 11), and the vessel clearly suffered from abrasion and breakage (Figs. 11, 13). The restorer took the liberty of completely repainting the scene, including the royal couple on the throne (Figs. 12–14).

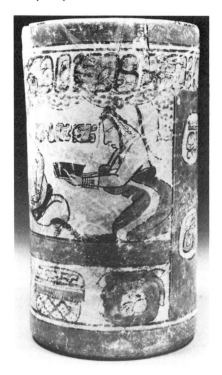 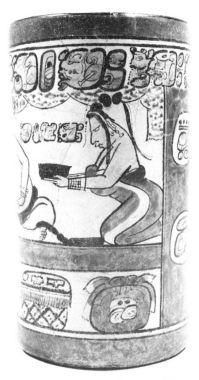

Fig. 13 Enema Vase, before and after reconstruction. Private collection. Photographs courtesy David Joralemon.

The hair of the woman, for example, was originally painted with manganese that ranges in color from black near the crown of the head to soft translucent brown in the top knots, but the entire coiffure is now solid black (Fig. 14). The headdress of the male figure, his hip-cloth, and all of the glyphs have been similarly covered with black paint, while the skin tones and details of the costumes are uniformly red instead of being modeled in hues of orange and rose.

The palace scene may show preparations for an enema ceremony as a form of ritual purification (Coe 1977b). An enema bag is held in the ruler's hand, and enema jars appear below the throne (Fig. 12). It would be unfortunate if this vase were to figure in any study of enema rituals, because some authors might conclude that animal deities or impersonators were important to purification ceremonies (Fig. 11). By repainting the attendants as animals, the restorer has rendered the scene useless for his-

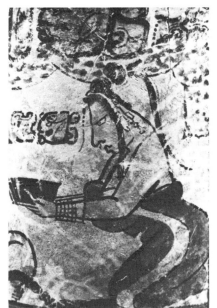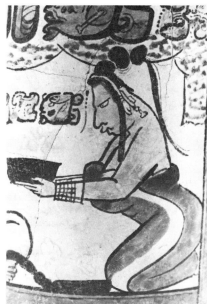

Fig. 14 Enema Vase, before and after reconstruction. Private collection. Photographs courtesy David Joralemon.

torical research. The vase no longer preserves the intent of the vase painter, and as a work of art, it lacks the coloristic effects that we expect from Late Classic ceramics. On the basis of the restored scene, the crack lines running through seemingly intact figures provide ample evidence of repainted motifs, but few would suspect the extent of the restoration.

CONCLUSIONS

While art dealers are naturally chary of releasing comparative views of restored vases, there is reason to believe that the vases examined here represent degrees of treatment commonly practiced on Classic vessels. Older collections of Maya ceramics, such as those of Dumbarton Oaks and the University of Pennsylvania, include vases with abraded sections and worn colors. These museum collections suggest that many preserved vases acquired through art dealers since 1960 have been substantially restored. Greek vases were heavily repainted by art dealers until around 1950 when collectors became more conservative. Since then, Classical vases in museums have been cleaned of new paints, varnish and wax. The removal

of these substances rarely harms Greek scenes because the vases were fired at high temperatures.[3]

The combination of low firing temperatures, percolation of water and soil conditions have rendered Maya vases more fragile. As we have seen in the case of the attendant figures in the last scene (Fig. 11), Maya vases can literally disintegrate through abrasion and water damage, and this area of the vase was probably sandpapered in order to prepare the surface for new paint. The techniques used by art dealers in the restoration of Maya vases—removing original paint by filing sherds, and sandpapering surfaces and creating new motifs with paints that can permanently stain vessels—make it advisable in the future to leave painted scenes as they are. These practices impede research on narrative vases, and if they continue, it may become impossible to understand the development of Maya vase painters and regional schools.

[3]Apart from my own interest in Greek vase painting, I am grateful for discussions on collectors and collections of Classical ceramics with Mr. Walter Bareiss, Member of the Governing Board of the Yale University Art Gallery and Visitor to the Department of Greek and Roman Art at the Metropolitan Museum of New York.

BIBLIOGRAPHY

ADAMS, RICHARD E.
> 1971 The Ceramics of Altar de Sacrificios. *Harvard University, Peabody Museum of Archaeology and Ethnology, Papers* 63 (1).

BEAZLEY, SIR JOHN D.
> 1956 *Attic Black-figure Vase-painters.* Oxford University Press, London.
> 1968 *Attic Red-figure Vase-painters.* 2 vols. Oxford University Press, London.

COE, MICHAEL D.
> 1973 *The Maya Scribe and His World.* The Grolier Club, New York.
> 1975 *Classic Maya Pottery at Dumbarton Oaks.* Dumbarton Oaks, Washington.
> 1977a Supernatural Patrons of Maya Scribes and Artists. In *Social Process in Maya Prehistory: Studies in honour of Sir Eric Thompson* (Norman Hammond, ed.): 327–347. Academic Press, New York.
> 1977b Ritual Enemas. *Natural History* 86 (3): 88–91.
> 1978 *Lords of the Underworld: Masterpieces of Classic Maya Ceramics.* The Art Museum, Princeton University Press, Princeton.

COGGINS, CLEMENCY
> n.d. Painting and Drawing Styles at Tikal: An Historical and Iconographic Reconstruction. PhD dissertation, Harvard University, 1975.

GIFFORD, JAMES C.
> 1974 Recent Thought Concerning the Interpretation of Maya Prehistory. In *Mesoamerican Archaeology: New Approaches* (Norman Hammond, ed.): 77–98. University of Texas Press, Austin.

GRIEDER, TERENCE
> n.d. The Development of Representational Painting on Pottery of the Central Maya Lowlands During the Proto-Classic and Classic Periods. PhD dissertation, University of Pennsylvania, 1962

KERR, JUSTIN, and B. KERR
> n.d. Some Observations on Maya Vase Painters. Paper presented at the Princeton University conference on the Style and Iconography of Maya Vase Painting, September 1981.

KUBLER, GEORGE
> 1975 *The Art and Architecture of Ancient America.* Penguin Books, Middlesex, England.
> 1977 Aspects of Classic Maya Rulership on Two Inscribed Vessels. *Studies in Pre-Columbian Art and Archaeology* 18. Dumbarton Oaks, Washington.

MacLeod, Barbara, and D. Puleston
 1979 Pathways into Darkness: The Search for the Road to Xibalba. In *Tercera Mesa Redonda de Palenque* (Merle Green Robertson, ed.) 4: 71–77. The Robert Louis Stevenson Schools, Pebble Beach, California.

Noble, Joseph V.
 1965 *The Techniques of Painted Attic Pottery.* The Metropolitan Museum of Art, New York.

Paul, Anne
 1976 History on a Maya Vase. *Archaeology* 29 (2): 118–126.

Plenderleith, H. J., and A. E. A. Werner
 1971 *The Conservation of Antiquities and Works of Art.* Oxford University Press, London.

Quirarte, Jacinto
 1979 The Representation of Underworld Processions in Maya Vase Painting: An Iconographic Study. In *Maya Archaeology and Ethnohistory* (Norman Hammond and Gordon Willey, eds.): 116–148. University of Texas Press, Austin.

Recinos, Adrian, D. Goetz, and S. G. Morley
 1950 *Popol Vuh: The Sacred Book of the Ancient Quiche Maya.* University of Oklahoma Press, Norman, Oklahoma.

Shepard, Anna O.
 1956 Ceramics for the Archaeologist. *Carnegie Institute of Washington, Publication 609.* Washington.

Taylor, Dicey
 1979 The Cauac Monster. In *Tercera Mesa Redonda de Palenque* (Merle Greene Robertson, ed.) 4: 79–89. The Robert Louis Stevenson School, Pebble Beach, California.

Thompson, J. Eric S.
 1939 Excavations at San Jose, British Honduras (Anna O. Shepard, appendix). *Carnegie Institute of Washington, Publication 506.* Washington.

Archaeological Buildings: Restoration or Misrepresentation

AUGUSTO MOLINA-MONTES

THE PRACTICE OF ARCHITECTURAL RESTORATION extends back into the centuries; it is probably almost as old as architecture itself. The conservation and restoration of architectural masterpieces is well documented since at least the times of Imperial Rome. It is not until the eighteenth century, however, that restoration begins to take form as a specific activity upon the basis established by Neo-Classicism and by the Romantic Movement which, incidentally, were also prime movers in the development of archaeology. Early in the nineteenth century, restoration began to develop a philosophy, a theoretical framework, with the writings of Louis Vitet, the first Inspector General of Monuments in France, and those of his successor Prosper Merimée. It was towards the middle of that century that the first dichotomy or confrontation developed in the new art; this confrontation is best exemplified by the personalities and philosophies of two great figures: Eugene Emmanuel Viollet-le-Duc and John Ruskin.

To Viollet-le-Duc, restoration implied the remaking of a building to a complete state—to leave it, if possible, in mint condition. He stated that "to restore a building is not to conserve it, to repair or to reconstruct it— but to reestablish it to a complete state such as may have never even existed at any given moment" (Viollet-le-Duc 1967: 14). True, he insisted upon a thorough appraisal of the remains and upon a comparative study of contemporaneous architecture of the region as a prerequisite of restoration, but in general, his insistence on returning the building to its pristine state opened the door to imagination and whimsy, and, especially in the hands of his followers, his doctrines served to falsify numerous architectural monuments.

Ruskin, on the other hand, proclaimed an absolute respect for the origi-

nal material and the fabric of ancient buildings; he reacted against the massive reconstruction that buildings were subjected to in his own time, and stated: "Restoration . . . means the most total destruction which a building can suffer. . . . a destruction accompanied with a false description of the thing destroyed. . . . Do not . . . talk of restoration. The thing is a lie from beginning to end . . ." (Ruskin 1963: 199).

Ruskin's demand for honesty is particularly touching: "Restoration may become a necessity. . . . look the necessity full in the face and understand it on its own terms. It is a necessity for destruction. Accept it as such, pull the building down, throw its stones into neglected corners, make ballast of them or mortar, if you will; but do it honestly and do not set up a lie in its place . . ." (Ruskin 1963: 200). Ruskin's critics say that his is a doctrine of fatalistic renunciation, that he preaches the decay of monuments, and that to him the fundamental value of an ancient building is its ruinous state. But this is not so. The truth is that Ruskin was a zealous conservationist recommending to all "to preserve, as the most precious of inheritances [the architecture] of past ages." And he pleads: "Watch an old building with anxious care; . . . bind it together with iron where it loosens; stay it with timber where it declines; do not care about the unsightliness of the aid; better a crutch than a lost limb . . ." (Ruskin 1963: 200).

Another great confrontation that arose in the theory and practice of architectural restoration, concerned the aesthetic as against the historical values of a building. Cesare Brandi has stated that the dialectic of restoration is represented by the equilibrium and conciliation between these two main values of a monument. Yet strong tendencies towards interventions destined to retain the "unity" and "purity" of style in architectural monuments destroyed much of their historical value by eliminating valuable elements that had, in time, become part of the historical stratification of the building.

An imposing figure in the history of restoration, the Italian architect Camillo Boito (1836–1914) was the first to attempt to reconcile the opposing tendencies and to establish standards in the restoration of architectural monuments. His work and that of his followers, particularly Gustavo Giovannoni, led to the International Congress of Restoration of Monuments, held in Athens in 1931, which issued the "Charter of Athens," the first international document to establish guidelines for architectural restoration.

The enormous destruction caused by World War II and the urgent need of tending to so many damaged buildings brought about a crisis in the

practice of architectural restoration in Europe. Soon, however, the need was felt to return to the established principles, which were reaffirmed and reexpressed in the Second International Congress, out of which arose, in 1964, the Charter of Venice.

We obviously do not have time, nor is it the theme of this volume, to go deeper into the many and complex aspects of the theory of restoration. Let it suffice to say that there are three very basic and important principles that are universally accepted:

1) Restoration attempts to conserve the materiality—the material aspects—of the monument;

2) The monument has a double value: a historical value and an aesthetic value;

3) It is necessary, in restoration, to respect both aspects so as not to falsify either the historic or the aesthetic document.

Despite the formulations and recommendations contained in the Charter of Athens, the Charter of Venice, and in other international documents that deal with the conservation of our cultural patrimony, the fact is that in practice, and in theory as well, the confrontations still exist; many architectural monuments are still suffering from overdoses of reconstruction or from the precedence given to aesthetic over historical values. However, even though there are differences of opinion and of execution in the restoration of buildings that still retain their functionality and the usefulness of their original architectural space, there is unanimity in the criteria that in archaeological buildings there is no need for either reconstruction or for massive intervention. There is almost universal agreement, at least in theory, as to the validity of the norms expressed in the Charter of Venice forbidding reconstruction and establishing consolidation and anastylosis as the only proper procedures in the restoration of archaeological buildings.

The Charter is quite explicit in this respect. It states that "the process of restoration . . . must stop at the point where conjecture begins, and . . . any extra work which is indispensable must be distinct from the architectural composition and must bear a contemporary stamp. . . ." Article Fifteen of the Charter which deals specifically with archaeological buildings, states:

> Ruins must be maintained and measures necessary for the permanent conservation and protection of architectural features and of objects discovered must be taken. Furthermore, every means must be taken to facilitate the understanding of the monument and to

reveal it without ever distorting its meaning. *All reconstruction work should, however, be ruled out a priori.* Only anastylosis, that is to say the reassembling of existing but dismembered parts, can be permitted. The material used for integration should always be recognizable, and its use should be the least that will ensure the conservation of a monument and the reinstatement of its form (ICOMOS 1971: LXX–LXXI; italics mine).

Needless to say that by "reconstruction" the Charter's prohibition means the rebuilding, with new materials, of parts or elements that have been lost, even when there is proof that those parts or elements existed in the past. It follows that it is even less permissible to rebuild parts or elements that only hypothetically could have existed in the original building.

And there are good and sound reasons for these norms. In buildings that can still be used functionally, there might be very pragmatic reasons for more latitude in the interpretation and application of the rules; but in edifices that are far removed chronologically from our culture and civilization, in buildings that can no longer be utilized for architectural purposes as the integral abode of man; in sum, in what I have been calling archaeological buildings, there is absolutely no need, in terms of practical use, aesthetic reasons or historic values, to reconstruct or to try to return the monument to its original state. In these instances, the architectural monument, through the ages, has taken on new cultural aspects and dimensions; it has lost many of its original architectural and aesthetic values and has acquired others, of a different kind; its value as a historical document, however, is enhanced by its condition as a "ruin," and this value is not to be tampered with for economic, touristic, nationalistic, pseudo-artistic or pseudo-didactic reasons. Conservation? yes!—Anxious care? certainly!—but not the gross reconstructions (even where there are good hypothetical evidences) that turn these great buildings into sad falsifications, cold and grotesque mockeries of their ancient glory.

In this regard, Cesare Brandi says: "It is manifest that a work of art has a life in time. For this reason, which is the same one which forbids falsification, the work of art cannot be taken back to its starting point as if time were reversible" (Brandi 1951: 21).

Restoration of Pre-Hispanic buildings in Mesoamerica formally began at the beginning of this century. Leopoldo Batres was appointed Inspector of Monuments in Mexico in 1885 and completed small-scale excavations in

Teotihuacan and other sites, but it was not until 1901 that he was "commissioned to repair and consolidate" the Building of the Columns in Mitla. Batres also carried out work on buildings in several other archaeological zones, among them Teotihuacan in 1905 and Xochicalco in 1910. Within a few years the restorations associated with the archaeological projects sponsored by the governments of Mexico, Guatemala, and Honduras, as well as by several private institutions, were initiated. In 1910 work was begun in Quiriguá. Between 1917 and 1920 extensive restoration work was carried out in the Temple of Quetzalcoatl and other buildings in Teotihuacan, in connection with the large archaeological project directed by Manuel Gamio. The Carnegie Institute projects at Uaxactún and Chichén Itzá were initiated almost simultaneously in 1934, and in 1935 work by the same institution was begun at Copán. The pyramid at Tenayuca was explored and restored between 1925 and 1926 by the Dirección de Arqueología of Mexico.

It can be said that with the notable exception of the work at Uaxactún, where several buildings were excavated and abandoned to their fate, the conservation and restoration of archaeological monuments and sites during this period was acceptable and in some cases very good, especially considering the time when this was being done. These projects, carried out before the Charter of Athens of 1931 and before modern ideas on conservation had received wide diffusion in America, showed respect for the integrity and authenticity of the buildings, for their aesthetic and historical values and for their original materials. In many restorations there was an evident intention to be absolutely truthful, to stop where hypothesis began, to reject reconstruction by analogy, etc., thus in several ways anticipating many of the present concepts of restoration theory and the norms dictated in the Charter of Venice.

This situation, however, did not last for long. As the number and rhythm of archaeological projects increased, the quality of restoration work decreased considerably, despite the improvements in archaeological techniques and despite the advances that had been made in Europe in restoration theory and practice.

In the decades between the 1940s and the 1960s, undue and exaggerated importance was given to the massive reconstruction of Pre-Hispanic architecture in Mesoamerica. These reconstructions have undoubtedly and seriously diminished the historic and even the aesthetic value of the many

monuments subjected to the process. The examples are myriad; I will mention only a few.

The Tlahuizcalpantecuhtli pyramid (or Pyramid B) at Tula was first explored and reconstructed in the years 1940–42. The building had been considerably destroyed and it is quite obvious from the photographs and drawings of those years that there was little evidence as to the original form of the stairway on the south side. As a matter of fact, there is reason to believe that it was first reconstructed without a stairway; the archaeological report covering the year 1942 states: "now that the pyramid has been reconstructed . . ." (Acosta 1944: 132). No mention of the stairway is made, and photographs of this period show no stairway.

In 1946, however, it was decided to reconstruct the stairway of Pyramid B (Fig. 1). Again the archaeological report corresponding to that year reads:

> On the south side of the pyramid restoration was begun on the central stairway, whose state of conservation was very poor. . . .
> the search for data and elements . . . gave the following results:
> 1) The width of the stairway was 7.14 mts. based on the remains of the alfardas.
> 2) *The imprint left by the first step* on the stucco floor.
> As can be appreciated, these elements were insufficient to attempt a restoration. . . . But *although not one step remained,* we did know that the pyramid had a stairway and that it was located towards the Great Plaza. . . . In view of the fact that any solution . . . would have been hypothetical, we decided to build a *conventional stairway* using the measurements of the steps on Building C, which most resembles Building B. In the alfardas we found the information that at the height of the eighth step [the eighth step according to Building C standards?] there are rectangular holes that served to support wooden beams vertically in the fashion of jambs to support a lintel. . . . there must have been additional supports in the central part of the stairway. This is the reason why the ninth and tenth steps were built in rough masonry . . . to show the possible places where the intermediate supports could have been originally, *as is the case in the Temple of the Warriors at Chichén Itzá* (Acosta 1956: 40; italics mine).

About fifteen years later, however, the intermediate supports were totally reconstructed in one of the many "possible places" and the ninth and

tenth steps were changed from rough to finished masonry. There was absolutely no basis for the reconstruction of these pillars; no new evidence had been found which would justify it.

If the west stairway was reconstructed on the basis of the imprint left by a step on a stucco floor, the colonnade in front of Pyramid B was also reconstructed with no more evidence than that offered by imprints of pillars on the same floor (Figs. 2, 3); there was little indication as to how those pillars were originally built or how they looked. The report of the 1943–44 excavations at Tula state:

> A curious fact should be noted; although 48 imprints of pillars
> have been found, *there has not been a single indication of the bodies of*
> *the pillars themselves.* It seems that at a certain epoch everything
> was destroyed and the materials carried away. The great amount
> of debris found at the site was largely made up of material carried
> there by rain runoff (Acosta 1945: 48; italics mine).

The indications as to what these pillars may have looked like came not from the colonnade of Pyramid B, but from the colonnade in front of the Palacio Quemado. These were tenuous indications at best, and further-more, I do not think that we can be certain that the pillars in front of Pyramid B were necessarily identical to those of the colonnade of the Palacio Quemado. Acosta generalized and stated that:

> After several years of hoping, we at last found the datum that was
> necessary to attempt, with justification, the restoration of the
> many columns in different buildings, in order that the public may
> have a more realistic idea of what these sumptuous Toltec con-
> structions were like when they were in use (Acosta 1960: 48).

I cannot accept these generalizations and analogies as valid nor can I believe that a small fragment can justify the reconstruction of hundreds of pillars and columns in different buildings of an archaeological site. At Tula the deceit is heightened by the fact that the pillars were made to look old (Figs. 2, 3); as reconstructed, they are of different heights, the stucco cover-ing is irregular and incomplete, etc. There was a deliberate attempt to deceive. The public in general, and even many professionals, think that they are looking at the original pillars and not at twentieth century recreations.

What has been said of the pillars of the colonnades applies as well to the columns and pillars on the inside of the Palacio Quemado. Figures 4–6 dramatically exemplify the proliferation of reconstruction and falsification.

It should by now be obvious that Pyramid B at Tula (Figs. 1–3) was

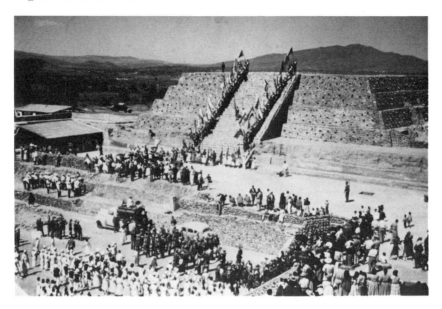

Fig. 1 Tula, Pyramid B *ca*. 1946. Official ceremony marking the completion of the restoration, without the colonnade. Photograph courtesy of Jorge Acosta.

reconstructed by analogy, that in some aspects it was tailor-made to re-
semble the Temple of the Warriors at Chichén Itzá. The problem is that
reconstructions in archaeological building have a tendency to become fos-
silized and accepted as archaeological evidence, to be accepted as truth.
Pyramid B is now used as proof of the relations between Tula and
Chichén Itzá; I do not mean to imply that these relationships did not
exist—there is much other evidence to indicate that they did—but I do
believe that arguments for these relationships, if based on certain elements
of the reconstructed Pyramid B at Tula, are worthless because these ele-
ments were *made* in the twentieth century to resemble those at Chichén
Itzá.

In 1962 and 1963 the building called the Palace of Quetzalpapalotl in
Teotihuacan was totally reconstructed. The report on this building indi-
cates the objectives of the reconstruction:

 . . . in the Palace of Quetzalpapalotl our project was much more
ambitious, since we intended to make a total reconstruction of the
building, making a [new] roof of wood and masonry as similar as
possible to the original (Acosta 1964: 38).

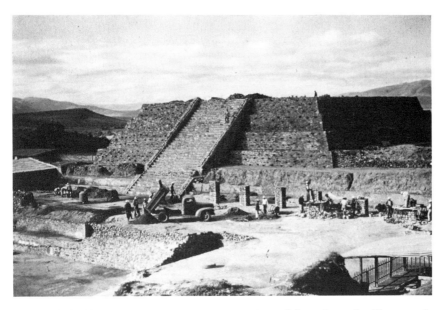

Fig. 2 Tula, Pyramid B *ca.* 1956. Reconstruction of the colonnade. Photograph courtesy of Jorge Acosta.

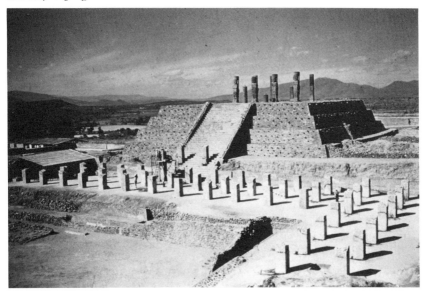

Fig. 3 Tula, Pyramid B *ca.* 1958. Pillars of the colonnade and stairway after the reconstruction.

Augusto Molina-Montes

Fig. 4 Tula, Palacio Quemado (Building 3) *ca.* 1956. No pillars or columns are apparent in any of the halls. Photograph courtesy of Jorge Acosta.

This was, of course, a serious mistake; it implied a deliberate falsification since it pretended to be as similar as possible to what was *supposedly* the original. An important and accepted norm in restoration theory and practice is that any completion of missing parts that is necessary for technical or aesthetic reasons, should be clearly differentiated from the old and should be frankly contemporary, although harmonious with the original.

The report on the Palace of Quetzalpapalotl further states that the reconstruction is hypothetical and largely based on analogy; the report reads:

> Of course we did not have all the antecedents, but we did have 80% of them, and could obtain the missing ones by analogy with other sites, or from the representations of indigenous temples painted on walls, and, in the last instance, the problem could be solved by deduction . . ." (Acosta 1964: 38).

Here again we have the same problem as with Pyramid B at Tula; the reconstructed palace will become fossilized and accepted as archaeological fact, when it actually is largely hypothetical and based on analogy. Just to mention one aspect, the proportion between the height of the pillars and the entablature is most probably wrong. Any studies of Mesoamerican

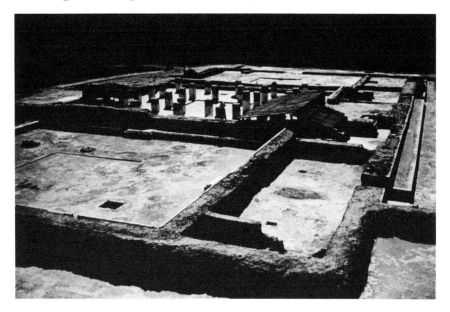

Fig. 5 Tula, Palacio Quemado (Building 3) *ca.* 1957. Pillars in the central hall have been reconstructed. Photograph courtesy of Jorge Acosta.

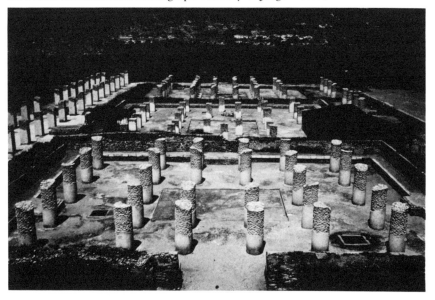

Fig. 6 Tula, Palacio Quemado (Building 3) *ca.* 1960. All the pillars and columns have now been reconstructed. Photograph courtesy of Jorge Acosta.

architecture, based on comparative analysis, will be on very doubtful ground if they take the Quetzalpapalotl palace into account.

The two examples we have seen are basically problems of historical falsification or, to say the least, of *probable* historical falsification. There are also cases of aesthetic falsification, based primarily on a lack of respect for the original materials and an unnecessary desire to "complete" the monument.

The Pyramid of the Magician at Uxmal (Fig. 7) was a noble building, but its huge and very steep platform showed the marks that time had left and was in need of urgent repair. A good consolidation of the loose stones of the facing and of the outer part of the core was necessary and would have been sufficient—as well as good restoration practice—and would have preserved the historic and aesthetic values of the monument. It was decided instead, in 1970, to reconstruct the structure by totally encasing it with a facing of new stone (Fig. 8). This was inexcusable from the point of view of good restoration practice and was unjustified on economic, aesthetic or technical grounds. The result is a cold caricature of the original. The reconstruction was also uneconomical, since a thorough consolidation of the core and facing stones should have been made before attempting to cover it with a new facing, which would then have been superfluous as well as undesirable.

The reconstruction of Building F at Cholula, in 1968–70, was a falsification from the historical and from the aesthetic point of view (Figs. 9, 10). A relatively small section of the original building (Fig. 9) and scant information about the rest, was used to reconstruct a huge pyramidal platform (Fig. 10).

You will notice that I have selected examples of Mesoamerican buildings in Mexico reconstructed by Mexican archaeologists. This is so, because these are examples to which I have closer access and on which I have firsthand information. But I would venture to say that much the same situation exists in other Mesoamerican sites. We know what happened at Zaculeu. I do not know, but I wonder, what happened as regards reconstruction at Tikal, Copán, Mixco Viejo, and other sites.

What was the cause of the massive reconstruction of Mesoamerican buildings? There is a saying that states: "name the sin but not the sinner." As a parenthesis I want to name, and render tribute to, a sinner. Jorge Acosta was one of the most competent and prolific practitioners of reconstruction. But he was a good archaeologist; he certainly did not intend to mislead, and he was honest in reporting the reconstructions that he exe-

Fig. 7 Uxmal, Pyramid of the Magician, before reconstruction.

Fig. 8 Uxmal, Pyramid of the Magician, after reconstruction.

Fig. 9 Cholula, Building F. The excavated portion is at the bottom and right, the partial reconstruction at the upper left.

Fig. 10 Cholula, Building F, after reconstruction.

cuted, the analogies he used, and his reasons for doing so. That is why it is so easy to pick on Jorge Acosta and single him out for criticism. Yet he was, in all good faith, sincerely attempting to conserve the archaeological buildings. The same thing can probably be said about all the individual archaeologists who reconstructed so many Pre-Hispanic buildings. On another occasion I have referred to these reconstructions as "atrocities"; perhaps these "atrocities" are the price we have had to pay for the privilege of still having Monte Albán, Xochicalco, Tula, Uxmal, Teotihuacan, and so many other archaeological sites, even if reconstruction has diminished their factual value.

If it was not individual archaeologists who caused the widespread practice of reconstruction, what then can explain this phenomenon? I think there are many causes and factors; we cannot analyze them all but some of them should be mentioned:

1) There was little or no knowledge of the basic principles of modern restoration theory and practice. This led to a misunderstanding of the objectives of restoration.

2) Many archaeologists wrongly supposed that the concepts and norms developed in other countries, mainly in Europe, were not applicable to Pre-Hispanic buildings in Mesoamerica.

3) Governments and institutions wanted a visible and, if possible, grandiose, return on their investment. They wanted buildings to be "finished" and complete, reconstructed as much as possible to their original appearance.

These and other factors brought about the institutionalization of massive reconstruction.

The situation took on such alarming proportions, that by the beginning of this decade protests began to appear against the degradation of our archaeological monuments and zones. In its Resolutions, the First Latin American Regional Seminar on Conservation and Restoration, meeting in Mexico City in 1973, stated: "The participants condemn the proliferation of works that—removed from the spirit of the Charter of Venice—falsify and anull values of the monument. . . . They reject reconstructions such as practiced at Cholula and Tiawanaku . . ." (SERLACOR 1973).

Earlier, a few isolated voices had demanded more authenticity in the conservation of archaeological monuments, but in general they had gone unheeded.

Of great importance was the First Technical Meeting on Conservation

of Archaeological Monuments and Zones held in Mexico City in July of 1974, jointly sponsored by the Instituto Nacional de Antropología e Historia, the Sociedad Mexicana de Antropología, and the Universidad Nacional Autónoma de México. The conclusions and recommendations of this meeting have been published in the *Boletín del Instituto Nacional de Antropología e Historia* (INAH 1974: 51–54) so we won't repeat them. It is important, however, to point out that for the first time, archaeologists, architects, conservationists, and others thoroughly discussed the problems related to the restoration of Pre-Hispanic monuments in Mesoamerica. The recommendations, in general, were towards closer adherence to international standards in the conservation of monuments, and specifically to avoid the practice of reconstruction in the restoration of archaeological buildings.

The recommendations were just that; recommendations that were not mandatory. Some archaeologists left them unheeded but others adopted the recommendations and, more importantly, the general spirit of the resolutions and set out to put them into practice in the field.

The restoration of buildings at Yaxchilán, directed by Roberto García Moll, were executed under the guidelines and according to the recommendations of the "First Technical Meeting on Restoration." They can be included among the good restorations of Mesoamerican buildings.

The restorations carried out by archaeologists in the Centro Regional del Sureste, under Norberto González, are excellent examples of good conservation practice. This is especially so in the recent restoration of the Ball Court at Uxmal, where the combination of good archaeological techniques and sound concepts of restoration have resulted in one of the best examples of anastylosis in Mesoamerican buildings.

Their work, and that of others, has demonstrated that the concepts and norms universally accepted and recommended for the conservation of architectural monuments are applicable to Mesoamerican buildings. We can no longer accept that—in order to save it—we must falsify or misrepresent our archaeological heritage.

BIBLIOGRAPHY

ACOSTA, JORGE R.

1944 La tercera temporada de exploraciones arqueológicas en Tula, Hgo., 1942. *Revista Mexicana de Estudios Antropológicos* 6 (3): 125–164.

1945 La cuarta y quinta temporadas de exploraciones arqueológicas en Tula, Hgo., 1943–1944. *Revista Mexicana de Estudios Antropolóqicos* 7: 23–64.

1956 Resumen de las exploraciones arqueológicas en Tula, Hgo., durante las VI, VII, VIII temporadas, 1946–1950. *Anales del Instituto Nacional de Antropología e Historia* 8 (37): 37–115.

1960 Las exploraciones arqueológicas en Tula, Hgo., durante la XI temporada, 1955–. *Anales del Instituto Nacional de Antropología e Historia* 11 (40): 39–74.

1964 *El Palacio del Quetzalpapalotl*. Instituto Nacional de Antropología e Historia, Mexico.

BRANDI, CESARE

1950 Principes de la restauration des oeuvres d'art. *Italie, L'amour de l'art* 30: 21–26.

ICOMOS

1971 *The Monument for the Man*. Marsilio Editor, Padua.

INAH

1974 La conservación de monumentos arqueológicos. *Boletín del Instituto Nacional de Antropología e Historia*. (ep. 2) 10: 51–54.

RUSKIN, JOHN

1963 *The Seven Lamps of Architecture*. Everyman's Library, London.

SERLACOR

1973 *Conclusiones del primer seminario regional latinoamericano de conservación y restauración*. Centro Regional de Estudios para la Conservación y Restauración de Bienes Culturales, México.

VIOLLET-LE-DUC, EUGENE

1967 *Dictionnaire raisonée de l'architecture française du XIe au XVIe Siecle* 8. F. de Nebele, Paris.

Donnan postscript, continued from page 50

also his motivation for combining figures and objects from different Moche scenes rather than copying from a single scene.

6) The ying-yang sign in the upper register carried no special meaning to this man. He recalls having seen something similar in a published Moche drawing, and included it in this scene because he thought it was interesting.

7) In producing the bottle, he was not attempting to create a falsification. He was motivated by his admiration of Moche ceramic art, and curiosity about how it was produced. The bottle was simply an attempt to duplicate the ancient techniques—he signed his name on the bottom of it before it was fired.

8) He eventually sold the bottle for a modest sum. When he last saw it, it was in perfect condition. Someone subsequently must have chipped and abraded the surface to make the bottle look old. In so doing, they removed his name from the bottom.

The man who made the bottle was dismayed that it had been altered and subsequently sold as an original. He has a profound respect for Moche artists and is ethically opposed to the production of fakes. Nevertheless, he is justifiably proud of his bottle, and expressed the hope that someday his children might know that he made it. Perhaps this report will serve that purpose.

Christopher B. Donnan
Lima, August 1982